Landscape with Smokestacks

LANDSCAPE WITH SMOKESTACKS

The Case of the Allegedly Plundered Degas

Howard J. Trienens

Northwestern University Press
Evanston, Illinois

Northwestern University Press
Evanston, Illinois 60208-4210

Printed in the United States of America

ISBN 0-8101-1820-3

Library of Congress Cataloging-in-Publication Data

Trienens, Howard J.
Landscape with smokestacks : the case of the allegedly plundered Degas /
Howard J. Trienens.
 p. cm.
 Includes bibliographical references.
 ISBN 0-8101-1820-3 (alk. paper)
 1. Goodman family—Trials, litigation, etc. 2. Searle, Daniel C.—Trials,
litigation, etc. 3. Degas, Edgar, 1834–1917. Paysage avec fumée de che-
minées. 4. Art thefts—France—Paris—History—20th century. 5. Art trea-
sures in war—France—Paris—History—20th century. 6. Holocaust, Jewish
(1939–1945)—Reparations. I. Title.
 KF228.G665 T75 2000
 345.73'0262—dc21

 00-010366

Book design by Dean Bornstein

for Paula

Contents

Illustrations

Foreword

The City News Bureau in Chicago was for many years the training ground for young journalists who went on to fame and fortune in their profession. Mike Royko, Ben Hecht, Kurt Vonnegut Jr., and others were brought up at the City News Bureau by old-fashioned reporters who placed a huge sign on the wall that trainees could not escape seeing many times each day. The sign, in big capital letters, read as follows: IF YOUR MOTHER SAYS SHE LOVES YOU, CHECK IT OUT.

Unfortunately, not many journalists today receive that kind of training, and many contemporary reporters fail to check things out before rushing to their computers or microphones or television cameras. Senator Daniel Patrick Moynihan once reminded a Senate witness that in our blessed, free country, all of us are entitled to our own opinions but not to our own facts. *Landscape with Smokestacks* is an effort to present facts, not opinions, and asks readers to reach their own conclusions.

Facts are sometimes messy, complex, and stubborn indications of ambiguity and confusion. Perhaps that is why so many journalists are impatient with complicated facts in a complicated world. But if no one digs into the facts, assumptions and conclusions can frequently be erroneous and misleading, which is what appears to have happened in this story. Journalists like to find heroes and villains. They reject the wise observation that maturity is learning to live with and accept ambiguity because ambiguity does not usually create an exciting story.

This is an unusual book. In some ways, it describes a legal case that never reached a judicial resolution. In some ways, it is a picture of one of the worst catastrophes in human history. And in some ways, it is an account of how journalists reported the controversy to the public. It is my hope that among its readers will be journalists who will grapple with the problem of reporting complexity when facing deadlines and writing what Phil Graham once described as the "rough first draft of history."

As the revolution in information technology explodes around us, the need for careful reporting is greater than ever. I saw some figures in the *New York Times* that put this in perspective. When President Richard Nixon resigned in 1974, newspaper and wire-service reporters in Washington, D.C., accredited to cover Congress outnumbered broadcasters almost two to one. Today that ratio is three to two in favor of radio and television journalists and technicians. And terse soundbites expressing quick conclusions are the order of the day.

Will anyone in the next century continue to remind all of us that IF YOUR MOTHER SAYS SHE LOVES YOU, CHECK IT OUT?

Newton N. Minow

Preface

HEIRS OF HOLOCAUST VICTIMS SUE TO RECOVER DEGAS LAND-
SCAPE STOLEN BY NAZIS. Stories with headlines like this were fea-
tured in the press nationwide. Television's *60 Minutes* produced a seg-
ment and broadcast it three times. Public television ran a one-hour
documentary.

Why all this interest in a legal fight over one work of art? Although
the systematic murder of millions of Jews in the Holocaust had been
widely publicized since the end of the war in 1945, it was not until the
1990s that attention was focused on the Nazi looting of Jewish prop-
erty during World War II. Swiss banks were accused of complicity in
Nazi theft of gold owned by Jews. Insurance companies and banks
were accused of confiscating property rightfully belonging to heirs of
Holocaust victims.

In 1994, a prizewinning book, *The Rape of Europa*, documented
the systematic looting of art from Jewish collectors during the occu-
pation of France and neighboring countries.[1] This led to charges that
art museums in Europe and the United States held artworks that had
been stolen by the Nazis. It was in this context that the lawsuit dis-
cussed in this book, brought by the heirs of Holocaust victims to re-
cover a work of art by Degas, generated publicity as a specific exam-
ple of Nazi looting.

As reported by the media, the story is straightforward. A landscape
by the famous artist Edgar Degas, owned by a Jewish art collector in
the Netherlands, was sent to Paris in 1939 for safekeeping. The Nazis
occupied France in 1940 and thereafter stole the landscape. The owner
and his wife were murdered in the Holocaust. Their heirs searched for
the Degas landscape after the war but did not locate it until, a half
century later, they found it in the possession of an art collector in
Chicago. The heirs sued to recover the landscape.

As the facts emerged in the course of litigation, however, the
straightforward media story turned out to be complex. One issue was

whether the Degas landscape had really been stolen. Another concerned the equities between the heirs and the collector who bought the landscape after it had been exhibited and published for decades.

A jury trial was set to begin on September 9, 1998. The media and the art world awaited the result. But none of the questions presented by the case was ever answered because the parties settled. Thus, there was no jury verdict, much less an appellate court opinion analyzing the issues. This book has been written to document facts that will enable readers to form their own opinion about the merits of the respective claims to the Degas landscape.

Written by counsel for the defendant collector, this book cannot escape the charge that it is slanted in his favor (but, it is hoped, not as slanted as the press and television coverage). It is an effort to lay out the story objectively. Each factual statement is supported by documents or depositions in the court record, unless otherwise specifically indicated.

Whatever the merits of the respective claims in the lawsuit, the story of *Landscape with Smokestacks* is an intriguing mystery. Solving the mystery is like putting together a jigsaw puzzle with some of the pieces (in this case, relevant documents) missing. It is not surprising that some documents are missing. What is surprising is that so many documents survived more than a half century.

This book's purpose is not to solve the mystery of what actually happened to the landscape. Rather, the purpose is to describe what lies beneath the surface of the press reports and television programs. This provides a more intriguing, if more ambiguous, story.

As what is known of the story of *Landscape with Smokestacks* is revealed, genuine questions emerge about the capacity of our judicial system to deal with cases of this kind and, perhaps more significantly, the performance of the media in such an emotionally charged atmosphere.

Landscape with Smokestacks

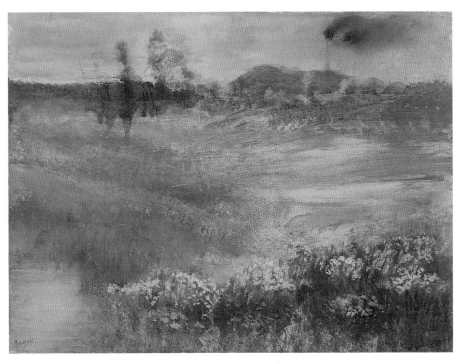

1. Landscape with Smokestacks (Paysage avec fumée de cheminées),
*a monotype by Edgar Degas, was painted sometime between
1890 and 1893.*

Chapter One

Edgar Degas Creates
Landscape with Smokestacks

THIS book covers events before, during, and after World War II. At the center of these events is a single work of art by Edgar Degas (see illustration 1, page 1).

Degas is famous for his paintings on canvas of ballerinas and nudes. The work of art that is the subject of this book is different. Known as *Landscape with Smokestacks* (*Paysage avec fumée de cheminées*) it is not a painting on canvas. It is a monotype mounted on a board. Specifically, it is an 11⅞-inch-by-15¾-inch "pastel over monotype in brown, green and purple oil colors on buff-colored based paper."[1]

Degas, born in 1834, was already an established painter when he began experimenting with monotypes. To create a monotype, the artist applies oils to a metal plate, rearranging them until satisfied. A paper is placed on the metal plate, and all is then placed into a press, transferring the image to the paper. Degas described the process as "drawings made with greasy ink put through a press."[2] The result is a picture on paper more luminous than if the artist had worked directly on the paper. "[I]t is inherent in the monotype process that only one or two impressions may be pulled from the plate before the ink is used up . . . a monotype is more like a drawing than a print: each impression is unique, or virtually so."[3] Hence the "mono-" in "monotype."

Degas produced hundreds of monotypes.[4] Some were in black and white, some with colored oils, and some with pastels added to the paper. Most were portraits; a few were landscapes.

As a doctoral student at Harvard University, Eugenia Parry Janis published the definitive work on the subject, entitled *Degas Monotypes: Essay, Catalogue and Checklist*, in 1968. Janis described Degas's technique in producing *Landscape with Smokestacks* as follows: "The artist set down the oil colors on the plate by smearing them in large diagonal strokes with a rag, allowing the color of the paper to show

through. Fingerprints, set down in rows, provide additional textures, especially along the horizon. The pastel additions are mostly concentrated in the lower areas of the format. . . . [T]he pastel colors were set down in little dots or dabs of yellow and pink. Degas matched green striations of monotype ink with green pastel. Prussian blue pastel was smeared into the sky to suggest smoke coming from the nearly eradicated monotype chimney."[5]

Janis identified the landscape as having been produced by Degas sometime between 1890 and 1893 and commented: "In the late landscapes, Degas never tried to hide a monotype base under pastel but instead deliberately set up a vibrating optical effect between the colored base and the more intensely colored and isolated pastel *taches* that rest on top of it."[6]

Degas continued to produce works of art for nearly two more decades. When he died in 1917, contemporaries were astonished at the profusion of his output, much of it still stored in his studio.[7]

It took four auctions at Galerie Georges Petit in Paris, each for three days, to dispose of Degas's collection. In the first three sessions, 1,139 paintings, pastels, drawings, and impressions were auctioned. In the fourth sale, from July 2 to July 4, 1919, 391 additional pieces ("including all of his sea/landscapes") were sold, one of which was *Landscape with Smokestacks*.[8]

This book undertakes to trace the unusual and oftentimes controversial journey of this pastel-over-monotype landscape from Degas's studio to the Art Institute of Chicago.

Chapter Two

Daniel C. Searle Buys the Landscape

THE Art Institute of Chicago is known worldwide for its extensive collection of Impressionist and Postimpressionist art. The works of Monet, Cezanne, Renoir, Degas, and many others line the museum's galleries. Of particular merit is the Art Institute's Degas collection. Impressive for its quality as well as its quantity, the collection, until recently, lacked a critical component—a Degas pastel-over-monotype landscape. When a New York art dealer informed the Art Institute in 1986 that such a work might be for sale, curators at the museum were eager to acquire it.

At that time, *Landscape with Smokestacks* belonged to Emile Wolf, a well-known art collector living in New York City. The landscape had long been a part of Wolf's large art collection in his Park Avenue apartment. Wolf had lent it to three major exhibits and allowed it to be published in major catalogues raisonnés, which are definitive listings of an artist's work assembled by art scholars and relied upon as primary sources for identifying and locating the works of a particular artist.

Wolf lent the landscape to the Rhode Island School of Design in Providence for an exhibit in 1984. He also lent the landscape for exhibition at the Finch College Museum in New York from 1966 to 1968. Later in 1968, the landscape was on loan to Harvard University's Fogg Art Museum in Cambridge, Massachusetts.

The Fogg Museum's 1968 exhibit focused on Degas monotypes, at that time a little-known and little-written-about aspect of his art and technique. Eugenia Parry Janis was responsible for identifying and locating as many Degas monotypes as she could. In addition to helping organize the exhibit, Janis also assembled a catalogue raisonné of Degas monotypes. Her book *Degas Monotypes,* published as the exhibition catalog, achieved critical success as the definitive work on Degas

monotypes and was acquired by major libraries in the United States and Europe. The landscape also appeared in a book by J. Adhémar and F. Cachin, *Degas — the Complete Etchings, Lithographs and Monotypes,* published in French in 1974 and in English in 1975.

Wolf had a reputation as an avid buyer of works of art. While he was eager to add to his voluminous collection, he was less willing to sell any of it. Margo Pollins Schab, who owns the Schab Galleries in New York, was one of many art dealers who dealt with Wolf over the years. "The problem with Mr. Wolf, you see, was that he was an impossible person to deal with," Schab said. "There were many, many dealers who had the same story to tell about Wolf; that they would be interested in something and he would name some crazy price and the person would say but that's insane and he would say that's okay, just tell the client I'm insane."[1]

When Wolf unexpectedly sold several pieces of his collection in the mid-1980s, Schab took this as a sign that he might be willing to sell more. Schab knew that Wolf owned *Landscape with Smokestacks* and was aware of its value to the Art Institute's Degas collection. In May 1986, she wrote to Douglas Druick, a longtime friend and art museum curator who had joined the Art Institute as its curator of prints and drawings in the previous year.[2] In the letter, Schab warned Druick that if the Art Institute wanted the Degas landscape, it would have to act promptly. News that Wolf had sold some of his collection would spread quickly, Schab informed Druick, and soon art dealers would be flocking to his apartment to see what else Wolf might be willing to sell. Druick and another curator in the prints and drawings department, Suzanne McCullagh, were both very interested in acquiring *Landscape with Smokestacks.* McCullagh regarded the landscape as "ravishing, very unusual."[3] However, Wolf wanted $900,000 for the landscape, a price the Art Institute could not then afford.

It is common practice for an art museum to seek out potential buyers for a work of art it desires but lacks the financial ability to acquire on its own. Curators frequently suggest works of art to the museum's patrons with the hope that the patrons will purchase the works and later donate them to the museum. Daniel C. Searle was just such a person (see illustration 2). The retired chairman of the pharmaceutical firm G. D. Searle & Company, Searle began collecting art in the

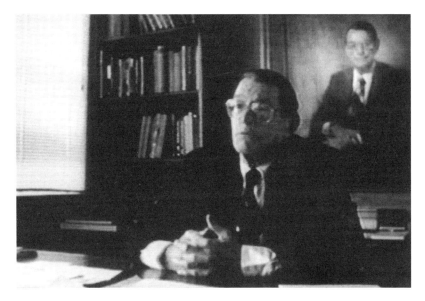

2. *The Art Institute looked to Daniel C. Searle, a member of the Board of Trustees and an art collector, to purchase* Landscape with Smokestacks.

1970s and had been a member of the Art Institute's Board of Trustees since 1983. Searle, a resident of a suburb of Chicago, had been focusing his collection on landscapes from late-nineteenth- and early-twentieth-century artists and had on several occasions received advice from curators at the Art Institute on works of art he might want to buy and consider donating. Searle had donated paintings to the Art Institute—one a famous grain stack by Claude Monet. Prior to hearing about *Landscape with Smokestacks,* Searle had purchased a seascape by Degas called *Plage à marée basse.* This was a work recommended to him by McCullagh, a longtime family friend who had grown up with Searle's daughter.[4] The art dealer who coordinated that purchase was Margo Pollins Schab, the same person who would later bring *Landscape with Smokestacks* to the Art Institute's attention. Over the years Searle had been generous with both his time and his money to the Art Institute. This, coupled with the fact that he had been collecting landscapes from Degas's era, made Searle an ideal candidate to buy *Landscape with Smokestacks.* As McCullagh said, "We [Druick and I] both felt that this was an immensely desirable piece at a price that would

be difficult for us to raise quickly and that we, therefore, might share the work with Mr. Searle in case it was of interest to him."[5]

In March 1987, McCullagh sent a letter to Searle that described the Degas landscape as well as two other works she thought might interest him. She knew that Searle and his wife frequently visited New York in the spring and fall to attend the auctions at Sotheby's and Christie's, and she invited them to view the Degas while they were in New York. McCullagh also informed Searle that Margo Pollins Schab was undertaking to sell the work for Wolf.

"[McCullagh] was very anxious for me to see this painting," Searle said. "[The Art Institute] thought it was a unique, a very unique work of art and something that the Art Institute would very, very much like to own, that the Art Institute would have bought it had they had the resources. Since they didn't, [they] were urging me to buy it."[6]

McCullagh made arrangements with Schab and Searle and his wife to view the landscape at Wolf's apartment. Wolf was absent at the time, and he and Searle never met. Though immediately impressed, Searle did not commit to buying the landscape because of its price. Schab said Wolf wanted $900,000. Searle thought that was too much money. The Art Institute's curators did not disagree.

"It was an exceptionally high price," Douglas Druick said. "It was also an exceptional work of art. In terms of what the market value is, I can't say exactly. I know what I believe the aesthetic value is. The question is, is there someone out there in the market who is going to pay? Sometimes the market for something like this is made up by two or three people."[7]

Price was not the only obstacle. Searle was reluctant to agree to buy the landscape until his other reservations could be addressed. "We were hesitant to make any commitment at the time until, one, we could have the Art Institute inspect the painting, verify that it was what it was represented to be," Searle said. "Secondly, we wanted to see the painting in our home; and third, I wanted to consult other parties to get a better idea for what the price of a painting like this would be at a public auction."[8]

Searle sent a color transparency of the landscape to Christie's to see how much it might fetch at auction. Christie's rough estimate was $600,000.[9] Searle left New York with the understanding that Schab

would try to persuade Wolf to lower the price while the landscape it-self was brought to Chicago by Schab so curators at the Art Institute could examine it.[10]

Druick described the steps taken to examine a work of art about to be purchased:

> There [are] questions that one asks about the work. Is the artist an artist of significance? The work in question by the artist, is the at-tribution firm? If the attribution is firm, is this a significant work by the artist? In that context, what part of the artist's career does it represent? Is that an area of the artist's production which is or is not represented by the collections as they stand? What is the condition of the work? Is the work in pristine condition? Has it been compro-mised by time? Has it been interfered with? Has it been damaged? Has it been restored? What does the provenance of the work tell us about who owned the work? Does it tell us anything about its exhi-bition history? And then finally, the question of the market price for the work — is it justified or justifiable in context of recent prices paid for the work?[11]

Druick explained that as a curator, when examining a work of art, he proceeds item by item through the criteria outlined above. If he en-counters what he termed a "green light," meaning no problems or concerns, he feels satisfied with that aspect of the artwork and contin-ues with the examination. If he encounters what he termed a "red light," meaning something does not look right, he conducts further re-search into that area until the problem is fully identified and, if pos-sible, resolved. Neither Druick nor McCullagh encountered any red lights when examining *Landscape with Smokestacks* for Searle. The fact that the landscape had been in Wolf's possession since 1951 was comforting. McCullagh explained: "[Wolf] had works of the highest quality, he cared deeply about them, about their proper publication, sharing them with others. He was generous in his knowledge and his collection."[12]

McCullagh also pointed to the landscape's publication history: "It's an extensively well-documented piece. [I]t has been published very often and by very distinguished and reputable institutions including color cover treatment in one publication [the exhibition catalog for the Rhode Island School of Design exhibit in Providence, Rhode

Island, in 1984], and it is in all the literature that one would want to be in."[13]

The documentation McCullagh was referring to is listed on the landscape's provenance. A provenance is a document listing the known owners or possessors of a work of art, together with a statement of where it has been described in the scholarly literature of the artist and the exhibitions where it has been publicly shown. The provenance of *Landscape with Smokestacks* and other information that Schab supplied both to Searle and to the curators at the Art Institute in 1987 were as follows:[14]

<div align="center">

EDGAR DEGAS
Paysage avec fumée de cheminées
(*Landscape with Smokestacks*)
Pastel over monotype in oil colors.
Red signature stamp lower left.

</div>

PROVENANCE: Atelier Degas (Vente IV, July 2 – 4, 1919, no. 45, illustrated); Nunes et Fiquet, Paris;

L. Wolff, Hamburg;

Collection of S. S. (Vente Galerie Georges Petit, Paris, June 9, 1932, no. 5);

Lutjens Collection, Holland;

Hans Wendland, Paris;

Hans Fankhauser, Basel;

Emile Wolf, New York (since 1951).

EXHIBITIONS: New York, Finch College Museum, "French Landscape Paintings from Four Centuries," Oct. 20, 1965 – Jan. 9, 1966, no. 39, illustrated;

Cambridge, Fogg Art Museum, "Degas Monotypes," organized by Eugenia Parry Janis, April 25, – June 14, 1968, no. 68 in exhibition, no. 277 in checklist, illustrated;

Providence, Rhode Island, The Museum of Art, Rhode Island School of Design, 1984, "From the Age of David to the Age of Picasso — French Drawings from a Private Collection," organized by Deborah Johnson and Eric Zaffran, no. 11, illustrated in color on cover.

LITERATURE: P. A. Lemoisne, *Degas et son oeuvre*, Paris 1946,
Volume III, no. 1054, reproduced;

E. P. Janis, *Degas: A Critical Study of the Monotypes*, New York
Graphic Society, Greenwich, Conn., 1968, catalogue no. 68,
checklist no. 277, illustrated;

J. Adhémar and F. Cachin, *Degas — the Complete Etchings,
Lithographs and Monotypes*, New York, 1975, p. 283.

In preparing the provenance, Schab drew upon information in a
1946 catalogue raisonné entitled *Degas et son oeuvre* by P. A. Lemoisne.
The first entry for *Landscape with Smokestacks* referred to the 1919
auction by the Degas estate, where the work was purchased by "L.
Wolff of Hamburg." The last entry in Lemoisne was a 1932 sale to the
"Lutjens Collection, Holland." Provenance information is often am-
biguous about whether the name listed is that of the owner, an art
dealer, or some intermediary.[15]

The balance of the Schab provenance was based on information de-
veloped by Eugenia Perry Janis in research for her book. Janis had
written to Emile Wolf in 1967 requesting additional information.[16]
Wolf replied in a handwritten note: "I purchased it [the landscape] in
1951 from Hans Fritz Fankhauser, a collector and marchand amateur
[part-time dealer] in Basel (Switzerland). He bought the Landscape
from Hans Wendland Paris."[17]

After examining the landscape and reviewing its provenance, the
Art Institute gave it a clean bill of health. Shortly afterward, Schab re-
ported to Searle that Wolf was willing to lower the price. In July 1987,
Searle bought *Landscape with Smokestacks* for $850,000. Searle stated
that in purchasing the landscape, he relied on Schab's reputation as a
prominent art dealer in New York and on his previous dealings with
her. Searle also stated that in making the purchase he relied on the ex-
pertise of both Druick and McCullagh as art scholars and curators:
"[Druick, McCullagh, and I] discussed the provenance in general. And
the Art Institute had no comments, no cautions, no concern about the
provenance that they called to my attention. . . . They did point out
that the painting had appeared at some prestigious exhibitions, forti-
fying at least my belief the painting and the exhibition history of the
— the ownership and exhibition history of the painting were — raised

no questions in my mind or the experts, i.e., Douglas [Druick] and Suzanne [McCullagh] at the Art Institute."[18]

Several years after he bought it, Searle lent the landscape to three museums for exhibition. In 1994, it was on loan to the Metropolitan Museum of Art in New York and to the Museum of Fine Arts in Houston, Texas, as part of a Degas exhibit arranged by Richard Kendall. Then Searle shipped the landscape overseas to the Ordupgaardsamlingen in Copenhagen, Denmark, for an exhibition running from October 1994 to January 1995. While the landscape was in Copenhagen, Searle contemplated selling it. By this time, Searle had already parted with most of his collection, which at its peak numbered from thirty to forty works of art. Disenchanted with ever-increasing prices that Searle attributed to an influx in the late 1980s of Japanese art collectors whose aggressive bidding tactics sent prices skyrocketing, Searle sold most of his collection at auction in 1989 because, he said, "prices for pictures got so high that it no longer made sense to me to buy more pictures. Since the majority of the pleasure of collecting art was being in the hunt, searching for suitable paintings, [and] since it was no longer possible to do that, I made the decision just to sell most of the collection."[19]

Searle elected not to sell the Degas landscape in 1989 with the bulk of his collection because he believed that, having paid so much more for the work than Christie's had estimated it would fetch at an auction, he would incur a financial loss.[20] In 1994, however, Searle received estimates that the landscape might be worth as much as $1.1 million.[21] Searle informed the president of the Art Institute, James Wood, in November 1994 of his intention to sell the landscape and donate the money to the Art Institute to fund the Audience Development Initiative, a special project Searle had been involved with that aimed to increase public interest in art and the Art Institute.[22] In reply, Wood "expressed his deep regret and concern on learning of your desire to sell the Degas. As you know this is a work as rare as it is beautiful, and one that from the moment they originally brought it to your attention, both Suzanne [McCullagh] and Douglas [Druick] have counted on for the collection. I realize that times and priorities change and that the last word on the disposition of works in your collection is of course yours, but the fact that this work represents the single most important

missing element in an otherwise uniquely comprehensive collection of Degas' work, would make its loss all the more painful."[23] Although Wood urged Searle to reconsider, the landscape was shipped from Copenhagen to the art dealer Schab in New York, who agreed to search for a buyer.[24] No offers in the million-dollar range were forthcoming, and the landscape remained in New York unsold throughout 1995.

The Goodmans Claim the Landscape

I N December 1995, Daniel Searle received a letter on a law firm let-
terhead captioned "Demand for return of Degas pastel known as
Landscape with Smokestacks." The letter stated:

> This firm represents Nick Goodman, one of the heirs of Friedrich
> Bernhard Gutmann, with regard to his family's efforts to locate and
> recover certain artworks that were spoliated during the Second
> World War.
>
> I understand that you or your family may have possession of a
> pastel by Edgar Degas known as *Landscape with Smokestacks* that
> originally came from the collection of Friedrich Bernhard Gut-
> mann. . . . I am writing to inform you that Mr. Goodman, along
> with his brother and aunt, are the rightful owners, and to demand
> the return of that work to them. . . .
>
> Prior to World War II, Friedrich Gutmann resided with his fam-
> ily outside Amsterdam and owned a number of significant art-
> works. Prior to the outbreak of hostilities, the family shipped part
> of their collection, including the *Landscape with Smokestacks* (also
> known as *Landscape or Little Landscape*), to Paris for safekeeping.
> In Paris, the pastel was apparently stolen by Nazi officials or agents,
> along with other artwork entrusted to the firm of Paul Graupe, 16,
> Place Vendôme. Friedrich Gutmann perished at Theresienstadt
> and his wife at Auschwitz. The theft of this painting was reported
> after World War II, and its recovery has been pursued by Bernard
> Goodman, Friedrich's son. Bernard Goodman recently died; Nick
> Goodman is Bernard's son.

The letter went on to say that the Goodman family found the land-
scape in the catalog published in connection with the 1994 Degas ex-
hibitions in New York and Houston to which Searle had lent the land-
scape.[1]

The letter was signed by Thomas R. Kline, a partner in the Wash-

ington, D.C., office of the Houston law firm Andrews and Kurth. Kline specializes in recovery of missing art and has been counsel in several highly publicized cases. One was the successful suit on behalf of a Cypriot church against an art dealer who had acquired mosaics stolen from the church during the Greek-Turkish war.[2] Another was the representation of a German cathedral in the recovery of bejeweled treasures stolen by an American soldier.[3] Kline was retained by Nick Goodman to recover missing art that had been owned by his grandfather, Friedrich Gutmann. Kline's fee would be contingent on the success of the recovery effort.[4]

The cryptic story of the Gutmann/Goodman family in Kline's letter has been told in great detail by Lili Gutmann, Friedrich (Fritz) Gutmann's daughter, on at least four occasions. One was an interview conducted by SHOAH Visual History Foundation in 1996. The foundation was created by Steven Spielberg to videotape and archive interviews of Holocaust survivors. Lili Gutmann also told about her family on CBS's *60 Minutes* in 1997, in her deposition in 1997, and in a documentary broadcast on public television in 1998.[5] Her story of the Gutmann family is as follows.

Friedrich Gutmann's grandfather, Bernhard Gutmann, was a German Jew living in the city of Dresden. Bernhard Gutmann founded the Dresdner Bank, which at the time was "a provincial bank in Saxony."[6] Dresdner Bank's rise to international prominence was closely linked to the unification of Germany in the second half of the nineteenth century. One of Bernhard Gutmann's thirteen children, Eugen, decided to move the bank from Dresden to Berlin, a city that Eugen saw as the focus of Germany's financial and political activity. There, the Dresdner Bank established itself as one of Europe's leading financial institutions. Eugen amassed a large fortune and invested some of it in a collection of silver and gold pieces from the German Renaissance. He also accumulated a voluminous collection of art, including the works of old masters such as Hans Burghmair, Lucas Cranach, and Botticelli.

Lili's father, Friedrich, was the youngest of Eugen's seven children. Friedrich was sent to London in 1912 to be the director of Dresdner's British branch. Within a year of his appointment, Friedrich married Louise von Landau, the daughter of a well-known Jewish banking

family in Europe. Friedrich and Louise's first child, Bernard, was born in England (thus a British citizen) and was christened, Friedrich's family having converted from Judaism to Christianity. Friedrich's grandson, Nick Goodman, explained: "My great-grandfather decided it would be better, for socioeconomic reasons, for them not to be Jews anymore."[7]

Shortly after Bernard's birth, World War I began. Louise and Bernard were deported from England to Germany. Friedrich was sent to a British prison camp on the Isle of Man in the Irish Channel. After more than three years as an interned enemy alien, Friedrich returned to the Continent as part of a prisoner exchange shortly before the war's end in 1918. As a condition of the exchange, Friedrich was sent to a neutral country, the Netherlands.

When World War I ended in November 1918, Friedrich was eager to return to Germany. But Eugen Gutmann asked Friedrich to remain in the Netherlands and open a Dutch branch of the Dresdner Bank. Louise and Bernard joined Friedrich in Amsterdam, and one year later Lili was born. Shortly after Lili's birth, Friedrich bought a mansion in Heemstede, just outside Amsterdam. The mansion had thirty rooms, attended to by seven servants.

Friedrich was already a trustee of his father Eugen's enormous art and silver collection when, in the 1920s, he began a private collection of his own. He bought some Dutch old masters and several early German portraits. In the late 1920s, Friedrich began purchasing modern works of art. In 1928, Friedrich bought a Renoir entitled *Apple Tree in Bloom.* He acquired the Degas *Landscape with Smokestacks* in June 1932 through the firm of Paul Cassirer and Company. Friedrich also bought another Degas, *Femme se chauffant (Woman Warming Herself).* Lili remembers those works of art hanging in the family home in Heemstede.

In the 1930s, Friedrich Gutmann's financial status became severely impaired. In the wake of a worldwide economic depression, Friedrich's bank failed.[8] Friedrich continued to conduct such banking business as he could on his own but was able to maintain his mansion and the family lifestyle only by going deeply into debt and by selling assets. By 1939, Friedrich had mortgaged his mansion and had borrowed heavily from a trust in which his brothers and sisters were beneficiaries.[9]

Three of Friedrich's old masters were sold before the war.[10] Friedrich also sold pieces of his father's silver collection before the war.[11]

In April 1939, Friedrich sent *Landscape with Smokestacks,* his other Degas, and his Renoir to Paris in care of the art dealer Paul Graupe & Co.[12]

In September 1939, Germany invaded Poland and France declared war on Germany. The Netherlands remained neutral, as it had been in World War I. Friedrich Gutmann was "not worried"; he expected that the Netherlands "would stay neutral, as [it] did in 1918."[13] Notwithstanding the declarations of war, there were no hostilities between France and Germany in 1939.

Lili, who had married an Italian in 1938, traveled from Italy to the Netherlands with her new husband to spend the 1939 Christmas holiday with her parents. Lili noted in traveling through Paris that all the lights were off for fear of German air raids. In the Netherlands, by contrast, lights were on as usual.[14] Lili recalled that visit to her parents' mansion: "I was with my husband and I do remember that in the house some paintings had been changed of place. They had been put in other places and some of the things were missing. And I said to my father, I said but what have you been doing? And he sort of laughed. He said, oh yes, I've been changing things. He didn't tell me anything because he was of the old school. He thought that his children, anything that had to do with business, we were not to know about that."[15]

In May 1940, Germany invaded France and, unlike during World War I, also invaded the Netherlands. The Nazi occupation made the lives of Friedrich and Louise Gutmann increasingly difficult, particularly because of their Jewish origins. Although Friedrich had converted and his children were raised as Christians, to the Nazis Friedrich Gutmann was a Jew. The Nazi occupation government in the Netherlands replaced Friedrich as the head of his own business with a German administrator — a practice referred to as "Aryanization." As a Jew, Friedrich was required to wear a yellow star, but he refused to do so. Friedrich could not even conduct the most rudimentary forms of business — which included withdrawing money from his own bank account. Lili said, "He was more or less a prisoner in his own home."[16]

But Friedrich Gutmann had influence with the Nazis through contacts in Italy, Germany's Axis partner in World War II. One of

Friedrich's sisters was married to Luca Orsini-Baroni, who retired from the Italian Ministry of Foreign Affairs with the rank of ambassador and who earlier in his career had served in Berlin. Either through Baroni or other contacts, an Italian commercial attaché stationed at The Hague looked in on Friedrich and Louise Gutmann. Through the Italian ambassador to Germany, Friedrich Gutmann acquired a letter of protection signed by Heinrich Himmler, head of the Nazi SS.[17]

Through diplomatic channels, Lili received in Italy a handwritten, undated two-sentence note from her father, in what she remembered was probably 1942.[18] One sentence told Lili that several works of art had been sent to the art dealer F. Stern in New York. The other sentence said that other artworks and antique furniture had been sent to the firm of Paul Graupe & Co. in Paris at 16 Place Vendôme. Of this note from her father, Lili said, "He is talking about having sent the three Impressionists—the Renoir and the two Degas—to Paris for safekeeping."[19]

Not all of Friedrich's art collection was sent out of the Netherlands. Apart from his private collection, Friedrich was a trustee to the Eugen Gutmann art collection, which included the collection of German Renaissance silver and gold objects. Lili said: "Of course [the Nazis] knew about it. It was internationally known—the Gutmann collection and the Eugen Gutmann collection. . . . So my father—with these things going on, didn't—had the idea he couldn't go away because he was entrusted to watch over his property. . . . It was really not a question so much of race and Jews, it was a question of rape. [The Nazis] were trying to get everything out of people, to take away everything from them. That is really the reason of the persecution of my parents."[20]

By 1943, the war was turning against Germany. The Italian army was losing to an Allied invasion force, which meant the end of any influence on the Nazis through the Gutmann family's relations with Italian officials.

Friedrich Gutmann tried to flee the Netherlands with his wife and join Lili in Italy. Friedrich and Louise managed to obtain travel visas to Italy, and Lili received permission from the Italian government for her parents to stay in Italy. Shortly thereafter, Lili received a telegram

from the Italian embassy in Berlin that said her parents had left Holland and were on their way. Lili said:

> I rushed to Florence, and I went to the station. In those days there was only one train — one international train with cars coming from — from Germany, so I went to the station. I waited at the station. My parents did not arrive.
>
> The next day I went back. Again my parents did not arrive. So we realized that something had happened. They had disappeared.
>
> So do you know what we do — what we tried to find out in Rome through Berlin through the Annuncio Apostolico [*sic*], the embassy of the Vatican in Berlin. And at last, I think after about a fortnight or something, we got the information that my parents had been taken to a concentration camp.[21]

After the war, Lili was able to piece together an account of her parents' fate: "One morning an officer of the SS arrived with a big car in front of the house in Heemstede and said to my parents, 'We've got your visas to go to Italy. You can leave. Go and pack your luggage quickly. You can take anything with you.' So they believed him. They believed him."[22]

Friedrich and Louise packed whatever they could and were taken to The Hague and put on a train to Berlin. Lili continued:

> "Why to Berlin?" they said. "Why to Berlin?" "Yes, because there is no direct connection to Italy. You have to go to Berlin," [the SS officer said]. So they arrived in Berlin and there they took them out of the train and they put them in another train and this train took them to a concentration camp at Theresienstadt. Well, you see, when we heard that they were in Theresienstadt, we tried with my then sister-in-law to help them; and I went with her to Rome and we were received by one of Benito Mussolini's ministers and we explained the whole case saying that they were my — my father and mother and that I was married to an Italian officer.
>
> And they — I must say the Italians did try to help us, but what happened on the twentieth of July was the fall of Mussolini and that was the end of Italy.[23]

When the war ended, Lili went to the Red Cross, where she said there were lists of people who had survived the concentration camps. Her "first day of peace" was spent going through these lists.[24] She did

not find her parents' names. Lili said that she later found out what had happened:

> [I]t seems that my father—that they came from Berlin for interrogation of my father and it always was about the art collections and that he refused to give this—to say take this family collection, because he said—"I can't because it belongs to the family. . . ." But they took him to the famous Clienefeston [sic] which was the special prison of Theresienstadt and that this is where these interrogations took place. When they saw that they couldn't get anywhere . . . they just killed him. That it seems from what people said—that they just kicked him to death. They just hit him and they saw him lying there somewhere in the—I don't know. . . .
>
> [T]hese people who told us said they heard my mother crying— she was crying all the time—but after he was killed . . . she knew if she would have survived she could have told what had happened. First thing they did they sent her off to Auschwitz. And when she arrived in Auschwitz . . . after a few days they killed her.[25]

In the Netherlands after the war, Lili and Bernard (who had anglicized his name to Goodman) began searching for their family's lost possessions. The Gutmann mansion had been completely stripped. Lili and Bernard filed claims with the Dutch government, reporting not only missing art but also missing furniture and other household items.

"Many things were found in Germany and came back here," Lili said about the immediate postwar years in the Netherlands. But although many works of art that had belonged to Friedrich Gutmann were recovered, many remained missing. According to Lili, she (residing in Italy) and her brother Bernard (residing in London and later Germany) "never stopped looking for the missing paintings."[26] (See illustration 3, page 22, for a photograph of Lili Gutmann and Bernard Goodman.)

The murders of Friedrich and Louise Gutmann occurred in the context of the mass murder of millions of Jews by the Nazis. The horrors of the Holocaust are widely known, their memory preserved in Holocaust museums in Jerusalem, Washington, D.C., and elsewhere.

Important background to the search for Degas's *Landscape with*

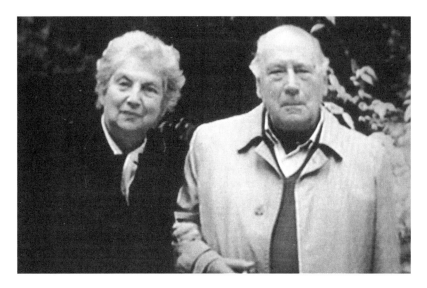

3. After the war, Friedrich Gutmann's son and daughter, Lili and Bernard, continued to search for their father's missing artwork.

Smokestacks is the vast scope of Nazi seizures of works of art. The Nazis planned and carried out systematic lootings of the great collections of art owned by wealthy Jewish families in Europe.

Lynn H. Nicholas, in her book *The Rape of Europa*, recorded the enormity of the Nazi looting of art. Literally tens of thousands of valuable works of art were seized. The works of the old masters and more modern works, such as those of the Impressionists, were seized indiscriminately. Adolf Hitler's agents selected old masters from the looted works of art for what Hitler hoped would be the world's greatest art museum, to be located in his hometown of Linz, Austria. Over 5,000 old masters, some purchased and some looted, were earmarked for Linz.[27] Hitler had no use for modern works such as those by the French Impressionists, many of which were regarded as "degenerate." Hermann Goering amassed the largest personal art collection, which included some 1,375 works, many of them looted.[28] Goering would exchange looted modern works of art for the old masters he preferred—for example, a dozen pieces by Renoir, Monet, or Degas for one Rembrandt.

The agency in charge of looting Europe's treasures, called the Ein-

satzstab Reichsleiter Rosenberg, or ERR, was the creation of the Nazi ideologue Alfred Rosenberg. The ERR was most active in France, where the art they stole was taken to the Jeu de Paume, a small museum near the Louvre. It was there that Hitler's agents, and Goering personally, took their pick of the loot. The balance was shipped by freight carloads to museums and warehouses throughout Germany. A Frenchwoman named Rose Valland employed by the ERR at the Jeu de Paume kept track of the shipments of Nazi-seized art and reportedly transmitted that information to members of the Free French Resistance.[29]

It is in this context of massive Nazi looting during the chaos of World War II that the trail of *Landscape with Smokestacks* must be followed.

Chapter Four

The Goodmans Sue Searle

IN his December 1995 demand letter, the Goodmans' lawyer, Thomas R. Kline, invited Daniel Searle to have his counsel contact him. Searle retained his regular law firm, Sidley & Austin, to investigate the basis for the Goodman demand for the return of *Landscape with Smokestacks*. The Sidley firm assigned the investigation to a partner in its New York office, Ralph E. Lerner, a specialist in art law and coauthor (with his wife) of the two-volume treatise *Art Law: The Guide for Collectors, Investors, Dealers and Artists*.

Lerner called Kline, and they agreed to an informal exchange of correspondence and documents in an effort to reach an agreement on the facts that could lead to a settlement.

The initial question raised by Lerner was whether the *Landscape with Smokestacks* purchased by Searle was the same Degas monotype that Kline said had been owned by Friedrich Gutmann. This question was resolved by a document found by Walter Feilchenfeldt, an art dealer in Switzerland known to both Lerner and Kline.

Remarkably, Feilchenfeldt's father had been present at a June 1932 auction in Paris representing the Berlin art dealer Paul Cassirer. At that auction, the then owner of *Landscape with Smokestacks*, L. Wolff of Hamburg, sold the landscape to a Helmut Lutjens of Holland. It turned out that Lutjens was the Amsterdam director of the Paul Cassirer firm and was bidding not for himself but on behalf of Friedrich Gutmann. The proof was a note, handwritten in the 1932 auction catalog by Feilchenfeldt's father, that the Degas landscape was bought by "Gutmann" of "Hemstede [*sic*] through Paul Cassirer Amsterdam," meaning its Amsterdam director, Lutjens. This explains why the provenance furnished to Searle and the Art Institute shows Lutjens as the buyer in 1932. Only the insiders at the Paul Cassirer firm knew that Lutjens was acting as agent for Friedrich Gutmann.

It having been established that the landscape bought by Searle in 1987 was the same work of art that Gutmann bought in 1932, Lerner asked Kline to provide documentation supporting the claim that the landscape had been stolen by the Nazis. Kline began by advising that "[a]round 1939, the Gutmanns sent three impressionist paintings (including *Landscape with Smokestacks*) to Paul Graupe & Co., an antique dealer located at 16 Place Vendôme, Paris, for safekeeping."[1]

Kline based the claim that the landscape had been stolen by the Nazis on two facts. First, a postwar letter from "Arthur Goldschmidt, who worked with Paul Graupe in Paris," advised that "Graupe deposited those paintings and certain other pieces of the Gutmann collection in a warehouse in Paris belonging to the firm of Wacker-Bondy." Second, "Wacker-Bondy advised that the German 'Einsatzstab Rosenberg' had seized everything on deposit with Wacker-Bondy from the Gutmann collection."[2]

Kline also described the efforts of Friedrich Gutmann's children to locate the three missing Impressionist paintings through the Dutch, French, and German governments and said that "Bernard and Lili never abandoned their search for the missing paintings."[3]

At Kline's request, Lerner produced the provenance furnished to Searle and the Art Institute by dealer Schab. Kline pounced on the name Hans Wendland shown in the provenance as being in the line of possession of the landscape. Kline replied to Lerner that the provenance "confirms that the Searles purchased the painting with knowledge that it came to them through the hands of one of the worst of the known profiteers from the Nazis: Hans Wendland and his partner in profiteering from looted Jewish property, Hans Fankhauser."[4] Kline reiterated "that the Einsatzstab Rosenberg seized the Painting in occupied Paris" and added "that the Painting passed eventually from Rosenberg to Wendland." Kline cited as authority for accusing Wendland of active complicity in the looting of Jewish art Lynn Nicholas's 1994 book, *The Rape of Europa*, and a 1946 interview of Wendland by the Strategic Services Unit of the United States War Department.[5] In the Nicholas book, "Hans Wendland, a German lawyer, possibly Jewish, who was a Swiss resident," is associated with a series of dealings in art seized by the ERR, including suggesting to Hermann Goering the use of diplomatic pouches to move looted

works of art to Switzerland, where they could be sold.[6] Given that Wendland's name was on the provenance, Kline wondered whether Searle knew, or was naive and unaware, "of the red flags that were flying."[7]

Correspondence between Kline and Lerner continued but became repetitive. Kline asserted again that "the document we have indicates that the Painting was seized by the Einsatzstab Rosenberg in Paris," with "infamous Nazi collaborators evident on the face of [the] provenance," adding that "[i]t was standard Nazi practice for the Gutmanns to be at the top of the list of those targeted for systematic looting."[8] One new subject related to photographs of Gutmann's three Impressionist works. Kline stated: "The Goodmans believe that the photographs of the painting were taken at the Jeu de Paume. Rose Valland, who had possession of these photographs, generally kept copies of pictures which the Germans took there for inventory purposes."[9]

In a May 1996 letter, Lerner questioned whether the documents relied upon by Kline, whatever they may show about other works of art, showed that *Landscape with Smokestacks* was, in fact, seized by the ERR. Lerner further questioned why the Goodmans took so long to discover the landscape, which had been exhibited and published for decades before Searle bought it.[10]

In his last letter, in June 1996, Kline reasserted that the Einsatzstab Rosenberg "seized the Painting from the Wacker-Bondy warehouse in Paris" — "there is no doubt this painting was seized by the Einsatzstab Rosenberg." Kline did not address the Goodmans' delay in locating the landscape.[11]

Meanwhile, *Landscape with Smokestacks* was withdrawn from sale and shipped by art dealer Schab from New York to the Art Institute of Chicago to hold pending resolution of the Goodmans' claim.

THE COMPLAINT

With the informal communications between lawyers Kline and Lerner going nowhere, in July 1996 the Goodman family sued Searle. The Goodmans' complaint was filed in the United States District Court for the Southern District of New York.[12] The plaintiffs were Lili

Gutmann and Nick and Simon Goodman, sons of Lili's deceased brother Bernard (collectively the "Goodman family"). The defendant was Daniel C. Searle.

The allegations of the complaint tracked Kline's correspondence. After alleging that Friedrich Gutmann purchased Degas's *Landscape with Smokestacks,* which was hung in the Gutmanns' home in Holland, the complaint continued:

> In or about 1939, Friedrich and Louise Gutmann, fearing for the safety of their property upon Nazi Germany's possible invasion and occupation of Holland, sent, amongst other works of art, three impressionist paintings, comprised of *Landscape with Smokestacks,* another work by Degas entitled *Femme se chauffant,* and a painting by Pierre Auguste Renoir known as *Appletree in Bloom,* to Paul Graupe & Co. ("Graupe"), an antiques dealer in Paris, France, for safekeeping. . . .
>
> The art collection of Friedrich and Louise Gutmann, including the three impressionist works sent to Paris, was spoliated by Nazi agents or collaborators, as were the rest of their possessions. . . .
>
> Bernard Goodman and plaintiff Lili Vera Collas Gutmann learned in 1945 that Graupe had deposited the Gutmann paintings, including *Landscape with Smokestacks,* in a warehouse in Paris belonging to the firm of Wacker-Bondy. . . .
>
> Bernard Goodman and plaintiff Lili Vera Collas Gutmann contacted Wacker-Bondy in 1945 regarding *Landscape with Smokestacks* and the other paintings, but were informed that the German Einsatzstab Reichsleiter Rosenberg (the "ERR" or "Rosenberg Action Team"), whose responsibilities included looting art from families who were identified as Jewish living in Nazi occupied areas, had seized everything on deposit at Wacker-Bondy from the Gutmann collection.[13]

The complaint asked the court to "[a]ward the Goodman family exclusive possession of *Landscape with Smokestacks.*"

THE MEDIA COVERAGE

Two days after the filing of the complaint in New York, two lengthy newspaper articles appeared, one in the *Los Angeles Times* (the home

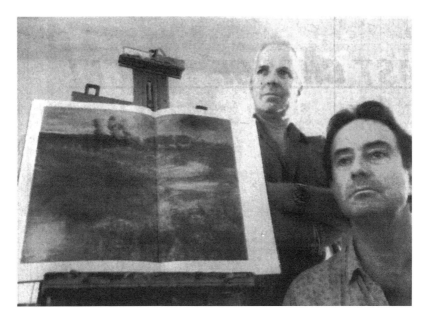

4. Nick and Simon Goodman, Bernard's sons, sought legal restitution, and their complaint became a media story.

of Nick and Simon Goodman) and one in the *Washington Post* (the home base of their lawyer, Kline).

The *LA Times* multipage article began on the front page of the "Metro" section. It featured a photo of Nick and Simon Goodman with a book open to a copy of the landscape (see illustration 4). The article treated the landscape as "a prime example of the ongoing struggles over art seized by the Nazis during World War II." The article reported that "as a precaution, Friedrich Gutmann sent three of the most valued Impressionist artworks — two by Degas and one Renoir — to a Paris art dealer for safekeeping." The article also described the Goodman family's efforts to recover those three works:

> Bernard Goodman died in 1994, never giving up hope that more of the Gutmann treasures would be found. He died, said Nick Goodman, "essentially penniless."
>
> By the mid-1960s, though, he had stopped searching — and stopped talking.

The Goodman brothers say they did not know about the Impressionist works until after their father died and their aunt in Italy told them. . . .

Family records mentioned the works, and the Goodmans had in hand three black-and-white photographs of the Impressionist works. Working undercover, art chronicler Rose Valland had photographed the art during the Nazi occupation of Paris, and after the war she gave the photos to Goodman.[14]

A five-column article in the *Washington Post* told the same story. The landscape was said to have been sent to Paris for "safekeeping" and taken from the Paris warehouse by the Nazi ERR:

Thanks to the heroic Louvre curator Rose Valland, who risked her life by keeping secret lists of thousands of confiscated objects, the Gutmann children eventually learned that some of their parents' art — including the two Degas and the Renoir — had been brought to the Jeu de Paume by the ERR. . . .

According to Searle's provenance, or the list of former owners, the Degas passed through the hands of two art dealers: a Nazi collaborator, Hans Wendland, and a Swiss man, Hans Fankhauser. Wendland helped the Nazis smuggle a great deal of art into Switzerland, where it could be sold for hard currency, or shipped to America and sold, according to [Willi] Korte [who] specializes in finding art stolen from Europe during World War II.[15]

On the same day, the *Wall Street Journal* ran a shorter story, again reporting that the landscape had been sent to Paris for "safekeeping in 1939 in a Paris art dealer's warehouse" and that "the Nazis later seized the contents of the dealer's warehouse," quoting Willi Korte as saying that "it's a picture-perfect plundering case."[16] (Korte is pictured in illustration 5.)

Those newspaper articles were soon repeated in truncated form by dozens of other newspapers across the country. The story did not die out. During the remainder of 1996, through 1997, and even after the settlement of the litigation in 1998, articles repeating the Goodman story kept appearing. The *Chicago Tribune* and the *Boston Globe* published feature articles during 1997. Magazine articles appeared in *Time, Newsweek, Chicago* magazine, and *ARTnews*.

The Goodman story was told on National Public Radio in 1996

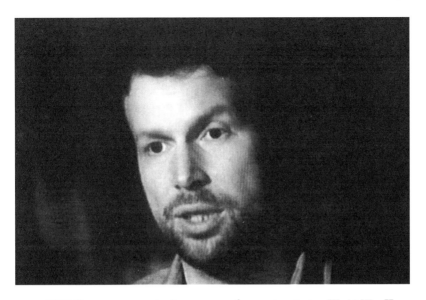

5. Willi Korte, an expert in the recovery of art stolen during World War II, took up the cause of the Degas pastel.

(during an interview with Willi Korte). And the Goodman story was featured in two nationally broadcast television programs.

The CBS program *60 Minutes,* which enjoys the highest ratings of any television news show, produced a segment on the Goodman story that was broadcast in January 1997 and rerun twice. Morley Safer introduced the segment by identifying *Landscape with Smokestacks* as "the central character in a drama, an eyewitness to a haunting tragedy: the plunder of tens of thousands of works of art by Nazis in World War II."

After telling the tragic story of Lili Gutmann's parents, Safer described "an important clue" that Lili had about her parents' plundered art, namely, "a letter she'd received from her father informing her that he'd sent a few paintings to a dealer in Paris for safekeeping: among them the Degas pastel." Safer continued: "But Paris was a major target for looting of Jewish collections, often with the collaboration of French dealers. After the war the Gutmanns were told by French officials that the Degas had been seized by agents of Reichsmarschall Hermann Goering and stored along with thousands of looted paintings in the museum of the Jeu de Paume."

Safer then turned to the discovery of the landscape in the 1994 exhibition catalog:

SAFER [*voice-over*]: Also listed in the catalog, in black and white, the current owner of the painting, Daniel Searle. The Goodmans contacted Searle at once and asked him to provide some proof that the Degas belonged to him. He sent them the painting's bill of sale and provenance, a document accepted in the art world as an official record of ownership, the equivalent of a painting's life history. The name "Gutmann" was nowhere to be found. But there was another name that meant a great deal to Willi Korte.

KORTE: Hans Wendland.

SAFER: Hans Wendland being?

KORTE: Hans Wendland being a German art dealer who, more than anybody else, was responsible for smuggling plundered works of art, plundered by the Nazis in France, into Switzerland for sale. The guy stands out like a sore thumb. I was absolutely flabbergasted.

SAFER: According to this report prepared by U.S. intelligence right after the war, Hans Wendland was a nasty piece of work and a vital part of the underground network that moved art plundered by the Nazis into the legitimate market. Working on commission for Goering and knowing the market, Wendland would select particular paintings from those stacked in the Jeu de Paume, smuggle them into Switzerland, and give them a new history.
[*Footage of provenance.*]

Mr. Searle's provenance convinced Korte that the Degas pastel took that same tortuous path. Wendland transferred the painting to another dealer in Switzerland, who in turn sold it to an American collector, who then years later sold it to Mr. Searle.

An hour-long documentary broadcast on public television in 1998 told the Goodman story in greater detail. Lili Gutmann displayed her father's wartime note as proof that the landscape had been sent to Paris for "safekeeping." The documentary told the story that the landscape had been stored at Wacker-Bondy, where it was seized by the Nazi ERR. Willi Korte, again identified as an expert in the recovery of

art stolen by the Nazis, stated: "When we received the provenance . . . it lists Hans Wendland, Paris, my first response was it can't be true that somebody would put Hans Wendland on the provenance. Now there was only one association you can draw with that name and that location during World War II and that is that it's a plundered work of art that found its way into the hands of Hans Wendland."[17]

Similarly, a book published after the complaint was filed treated the Goodmans' allegations as established facts. *The Lost Museum*, by Hector Feliciano, states that *Landscape with Smokestacks* had been "sent to Paris for safekeeping," where the ERR "seized" Gutmann's "Degas paintings and the Renoir." Feliciano further wrote that the two works by Degas and the Renoir were "confiscated" by "Bruno Lohse, deputy director of the ERR" and "were sold or exchanged by the Nazis in the European art market." To Feliciano, the name Hans Wendland on the provenance was "the proof we needed" that the Nazis stole the landscape because Wendland "was the active mastermind of the looted art smuggling ring between France and Switzerland." Wendland was "a friend of Mme. Wacker-Bondy" and "also rented a room in Mme. Wacker-Bondy's store where he kept many paintings," the Wacker-Bondy store being the very place "where the Goodmans' Degas was stored and looted."[18]

The Goodman story continued to be publicized even after settlement of the litigation. The September 1998 edition of the *Art Newspaper* led the story of the settlement with the line "Nazi war loot restitution" and continued:

> The pictures—two Degas and a Renoir—were seized by the Einsatzstab Reichsleiter Rosenberg (ERR), a Nazi confiscation agency, according to the Goodmans. The Degas ended up in the inventory of the German dealer Hans Wendland, who conducted a lucrative trade in Switzerland with members of the Nazi leadership, including Hermann Goering. . . .
>
> By purchasing the Degas, the Art Institute avoids having its curators testify publicly about their counsel to Mr. Searle, and their failure (admitted in pretrial depositions) to notice or inform one of the museum's major benefactors that a Nazi figured prominently in the picture's provenance—a glaring red flag to specialists in the field of art restitution.

Some of the newspapers and magazine articles and the two television programs made brief references to Searle's questions about whether the landscape was actually stolen and where the Goodmans were during the decades that the landscape had been exhibited and published before Searle bought it. But emphasis was universally focused on the tragic fate of Friedrich and Louise Gutmann and the Goodmans' story that the landscape had been sent to Paris for safekeeping, where it was stolen by the Nazis.

THE CASE IS TRANSFERRED TO CHICAGO

The first event in the court case filed by the Goodman family was a move by defendant Searle questioning whether the case was properly in the federal court for the Southern District of New York (Manhattan). By what right were two British citizens residing in California (Nick and Simon Goodman) and a Dutch citizen residing in Italy (Lili Gutmann) suing a resident of Illinois in a federal court in New York? This dispute over ownership of a work of art did not present any question of federal law. But the case was properly in a federal court because the Goodman plaintiffs resided in different states (and countries) than Searle. This invoked the so-called diversity jurisdiction of federal courts.

But why New York? Searle was preparing to file motions contending that (1) New York had no jurisdiction over him, which meant that the case should be dismissed; (2) New York was an improper venue, which meant that the case should either be dismissed or be transferred to an appropriate venue; and (3) in the alternative, the case should be transferred to the Northern District of Illinois (Chicago) as the most convenient forum to hear the case.

The case was assigned, by random selection, to Judge John E. Sprizzo, who had been appointed to the federal bench by President Ronald Reagan in 1981. Judge Sprizzo had an unusual rule in his court that no party could file a motion until the parties explained to him the nature of the proposed motion, in this case Searle's proposed motion to dismiss the case or transfer it to the Northern District of Illinois.

At the meeting with counsel for Searle and the Goodmans, Judge Sprizzo expressed his view that the case did not belong in New York.

Judge Sprizzo indicated that if the Goodmans resisted and required Searle to file a formal motion and briefs, the judge might order sanctions (usually requiring the Goodmans to pay Searle's legal fees in preparing the motions and briefs) if, after the pleadings were filed, the Goodmans then agreed to a transfer of the case to Chicago.[19]

Having heard Judge Sprizzo express his view, the Goodmans' counsel agreed that the case should be transferred to the Northern District of Illinois. The Goodmans' counsel agreed to the transfer "in the interest of avoiding litigation of the jurisdiction and venue issues."[20] He asked that the case be transferred — not dismissed, which would require a refiling in Chicago — to avoid "costs and inconveniences on the Goodmans, who have already issued a number of document subpoenas."[21] No mention was made of any other consequences of transfer as opposed to dismissal.

In September 1996, Judge Sprizzo entered the following order:

> Defendant Daniel C. Searle having indicated an intention to move, alternatively, (1) to dismiss this case for lack of jurisdiction over the person of the defendant; (2) to dismiss this case for improper venue; and (3) to transfer this case to the United States District Court for the Northern District of Illinois; and
>
> Plaintiffs Nick Goodman, Simon Goodman and Lili Collas Gutmann having expressed a willingness to transfer this case to the United States District Court for the Northern District of Illinois;
>
> IT IS ORDERED that this case is HEREBY TRANSFERRED to the United States District Court for the Northern District of Illinois.[22]

Upon transfer to the federal court for the Northern District of Illinois, the case was assigned, by random selection, to Judge George W. Lindberg, who, in 1989, after ten years of service on the Illinois appellate court, had been appointed to the federal bench by President George Bush. In November 1996, Judge Lindberg ordered that discovery be cut off by June 1997 and set the trial for November 1997.[23]

Chapter Five

What Happened to the Landscape?

A FTER a complaint is filed, the parties embark upon discovery, which includes production of all documents relevant to the case and depositions of prospective witnesses. The Goodmans' lawyers produced literally thousands of documents generated before, during, and after World War II. Some of those documents were in the English language, but most were in French, German, or Dutch.

Analysis of documents produced by the Goodmans together with further investigation revealed a story far more complex than that reported by the media.

Safekeeping?

In April 1939, works of art, including Friedrich Gutmann's Renoir and two works by Degas, were sent from his home in the Netherlands, in care of the art dealer Paul Graupe & Co., to the storage place maintained by Madame Wacker-Bondy on Boulevard Raspail, Paris.[1] The Wacker-Bondy establishment, sometimes described as a warehouse but looking more like a large apartment, was used by Paul Graupe & Co. to store works of art not being shown at the firm's gallery at 16 Place Vendôme, Paris.[2]

Why were the three Impressionist works sent to Paris? The Goodmans alleged that *Landscape with Smokestacks* was sent for safekeeping. There is no contemporaneous document indicating what Friedrich Gutmann's purpose was in sending those works of art to Paris in April 1939.

In World War I, Germany invaded France. Holland was neutral. Fearing another invasion by Germany, France built the Maginot line in the 1930s. Living in the Netherlands, Friedrich Gutmann was "not worried"; he expected the Netherlands to remain neutral again. Under

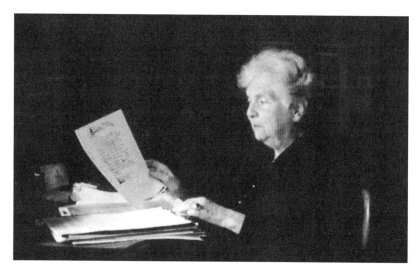

*6. In a note written in 1942, Lili Gutmann's father mentioned the three
Impressionist paintings he had sent to Paris.*

those circumstances, if Gutmann in April 1939 was concerned about
the outbreak of war with Germany and wanted his works of art in a
place for safekeeping, would Paris be the place to send them? Could
Gutmann have believed that the Maginot line made Paris a safer place
to keep works of art than his Netherlands home?

Did Friedrich Gutmann send works of art, including *Landscape
with Smokestacks,* to Paris not for safekeeping but to be sold? Paris was
an active art market.[3] Gutmann was deeply in debt. He needed money
to live on, including to maintain his thirty-room mansion. He had sold
other works of art before the war.

Lili Gutmann said that her father sent the landscape to Paris for
safekeeping. In the 1998 television documentary, she specifically ad-
dressed the contention that *Landscape with Smokestacks* had been sent
to Paris for sale. Lili Gutmann pointed to the note she had received in
Italy from her father in 1942 (shown in illustration 6) and stated: "The
whole clue of all this is this tiny piece of paper where he is talking
about having sent the three Impressionists—the Renoir and the two
Degas—to Paris for safekeeping. So why did he send me this note—
why, because he wanted me to know that these paintings had not been
sold."[4]

Lili Gutmann's translation of the undated two-sentence "tiny piece of paper" in her father's handwriting is as follows:[5]

Very Important:

For your information eventually for later remember, that some important objects of art are in New York with F. Stern—Drey, 230 Central Park West—Bolivar Hotel—as the Bosch, the Frans Hals and the Veit Stoss angels. Further* Arthur Goldschmidt (firm Paul Graupe before in Paris, 16 Place Vendôme)—now also in New York —has also a lot of valuable pieces, as the Hans Baldung Grein, the Signorelli, 1 Renoir, 2 Degas and many 1a pieces of French furniture and other items.

(signed) P.

* his address in New York is unknown to me as he went there only later.
** the signature P. stands for Papi and is the way my father mostly signed his letters to me.

This note was all that Lili Gutmann knew about the disposition of her father's artworks until after the war.[6] Neither sentence of this two-sentence note refers to safekeeping.

Although the note from Friedrich Gutmann is inconclusive, there are documents from F. Stern and Paul Graupe stating that the works of art referred to in the note were sent to them to be sold.

The first sentence of the note states that three works of art had been sent to F. Stern in New York: "the Bosch, the Frans Hals and the Veit Stoss angels." In September 1945, Stern wrote to Bernard Goodman "to advise as follows: In October, 1938 and prior to September, 1939, he [your late father] delivered to me for sale on his behalf five items." Among the items Stern listed were the following:

1. 2 Angels in wood by Veit Stoss;
2. 1 Painting *Temptation of St. Anthony*, by Bosch; and
3. 1 Painting portrait of a man by Frans Hals.

Those items sent to F. Stern for sale are the three items described in the first sentence of Friedrich Gutmann's note. Stern also advised Bernard Goodman that "[d]uring the month of July, 1941, item 2 above [the Bosch] was sold for the agreed price of $11,000." Item 3 [the Hals] was sold in June 1945. The other items remained unsold.[7] Thus,

the items listed in the first sentence of Friedrich Gutmann's note were sent to New York for sale. One had already been sold before Lili Gutmann received her father's note in 1942, but there is no basis to infer that her father, confined to his home in Nazi-occupied Netherlands, knew that when he wrote the note.

The second sentence of Freidrich Gutmann's note states that "a lot of valuable pieces" had been sent to "Arthur Goldschmidt (firm Paul Graupe before in Paris, 16 Place Vendôme)," listing among other items "the Signorelli, 1 Renoir, 2 Degas and many 1a pieces of French furniture." The "Signorelli" and "5 Armchairs Louis XV" were recovered from Germany after the war. The Gutmann estate needed proof that those items had belonged to Gutmann. Paul Graupe provided that proof by certifying "To whom it may concern" as follows:

> I received on consignement for sale at 16 Place Vendôme, Paris the following objects from the owner, Mr. Fritz Gutmann of Heemsted, Holland, before the outbreak of the War:
>
> 1. Painting *Baptism of Christ* Signorelli
> 2. 5 armchairs Louis XV, with petit points[8]

Thus, like the items sent to Stern in New York, items Friedrich Gutmann listed in his note were sent to Paul Graupe & Co., Paris, for sale.

Further information about what was done with Gutmann's works of art after their arrival in Paris is contained in a November 1945 letter from Arthur Goldschmidt to Paul Simon (a New York lawyer representing the Gutmann estate). This is the letter relied upon by the Goodmans' lawyer Kline to establish that Gutmann's landscape had been deposited in "a warehouse in Paris belonging to the firm of Wacker-Bondy." Goldschmidt's letter confirms that, and tells more.

> Before the outbreak of the war we contacted Mr. Gutmann telling him that we cannot take any responsibility for the goods we had on consignment from him. Mr. Gutmann answered us by letter that he did not want his goods back and that he preferred them to stay with us in Paris. By the outbreak of the war, the French government sequestrated all goods which they found in our Galleries at 16 Place Vendôme with the order given to us as well as the concierge of the building that no object is allowed to be moved out of the place. . . .
>
> The pictures we had on approval from Mr. Gutmann I was able

to take them out of the house before the sequestre was laid on and I delivered them to our French forwarding agent, the house of Wacker-Bondy, 6 Boulevard Raspail on storage. If this house kept the pictures in their own place or gave them on to another storage house, I don't know.

I am enclosing list Number 2 containing the above mentioned pictures.[9]

Goldschmidt's enclosed "list Number 2" identifies twelve Gutmann works of art transferred to Wacker-Bondy to escape the "sequestre," including the Renoir, *Landscape with Smokestacks,* and the other Degas, *Woman Warming Herself.*

Goldschmidt referred to the works of art received from Gutmann as having been "on consignment." When a piece of art is sent to a dealer on consignment, it is available for sale, and the dealer to whom it has been consigned is authorized to sell it on the consignor's behalf.[10]

Goldschmidt's letter also states that Gutmann's three Impressionist works, sent from the Netherlands to the Wacker-Bondy storage place in April 1939, had been transferred to the "Galleries at 16 Place Vendôme," the salesroom of Paul Graupe & Co., from which Goldschmidt was able to take the works back to Wacker-Bondy to avoid the postoccupation sequester. In addition to being in the salesroom of Paul Graupe & Co., one of Gutmann's Impressionist works (the Degas *Woman Warming Herself*) was exhibited at the salesroom of the André Weil Gallery in June 1939.[11]

The use of the term "safekeeping" as applied to Friedrich Gutmann's three Impressionist works in Paris may have originated when Gutmann's purpose in sending them to Paris in 1939 was confused with Goldschmidt's purpose in moving them from the sales gallery at Place Vendôme to storage at Wacker-Bondy in 1940 to escape their sequestration at the gallery. The latter was described in 1946 as *mise en garde* (safekeeping).[12]

In an interview in 1945, Walter Andreas Hofer, who had known Friedrich Gutmann since the early 1920s, said that Gutmann had told him in 1940 that "[h]e had given some of his objects to either Goldschmidt or Graupe on commission . . . and that they were available for purchase in Paris or Cannes."[13]

In 1946, Paul Graupe's son, Thomas Grange, reviewed his father's

records and described the works of art sent by Friedrich Gutmann to Paul Graupe & Co. as having been received *en commission*, corresponding to "on consignment" in English.[14]

STOLEN BY THE NAZIS?

Whether *Landscape with Smokestacks* was sent in 1939 to Paris for safekeeping or to be sold, what happened to the monotype after it was moved to Wacker-Bondy in 1940? Documents reveal that many of the works of art in storage at Wacker-Bondy were removed for sale between 1940 and 1942 and others were seized by the Nazis in 1942. In which category was *Landscape with Smokestacks?*

A document prepared by Paul Graupe's son, Thomas Grange, in August 1946 lists forty-seven works of art "turned over to Madame Wacker-Bondy by the firm of Paul Graupe & Co. in the name of Monsieur MUIR," a fictitious name.[15] Included in Grange's list of forty-seven missing works of art are the twelve pieces listed in Goldschmidt's letter as having been received on consignment from Friedrich Gutmann, including his Renoir and his two works by Degas.[16] Grange supplied both the list and photos of the works to "M. Dreyfus of the Jeu de Paume."[17] Dreyfus was the director of the French commission charged with recovery of lost or stolen works of art.

Six of the Gutmann pieces were removed from Wacker-Bondy in 1941 pursuant to a sale negotiated personally by Friedrich Gutmann with the German art dealer Karl Haberstock. Arthur Goldschmidt described the circumstances of that sale as follows:

> During the early summer months of 1941, I received the visit of Mr. Karl Haberstock (a well-known picture dealer in Berlin) in Cannes where I stayed at this time. He showed me a letter given him by Mr. Fritz Gutmann in which Mr. Gutmann asked me to give the necessary orders so that Mr. Haberstock when back in Paris could look at the pictures and take possession of them. Knowing the handwriting and signature of Mr. Gutmann, by having done business with him for years, I recognized this letter to be legitimate and wrote a letter to Wacker-Bondy to deliver many pictures according to his wishes to Mr. Haberstock. Thus, I am pretty sure that Mr. Haberstock, if not all, bought the greater part of this picture collection by negoti-

ating this business personally with Mr. Gutmann on his way back from Paris.[18]

A bill of sale handwritten by Friedrich Gutmann confirms the 1941 sale to Haberstock of six works of art stored at Wacker-Bondy.[19] The six pieces sold to Haberstock do not include Gutmann's three Impressionist works. Haberstock was not interested in French Impressionist art.[20]

In addition to the Gutmann works of art on consignment, Goldschmidt sent to Wacker-Bondy, under the Muir name, works Paul Graupe owned solely or owned jointly with Hans Wendland and works received from other owners. Many of those pieces were removed from Wacker-Bondy and sold in 1940 and 1941.[21] Other works remained at Wacker-Bondy.

The Goodmans' claim that *Landscape with Smokestacks* was stolen by the Nazis rested on two facts: first, that the landscape had been transferred by Goldschmidt of Paul Graupe & Co. to the Wacker-Bondy storage place, and, second, that "Wacker-Bondy advised that the German Einsatzstab Rosenberg had seized everything on deposit with Wacker-Bondy from the Gutmann collection."

This leaves open the question of whether the landscape was still at Wacker-Bondy when the ERR arrived.

The documents produced by the Goodmans did not come from Mrs. Wacker-Bondy herself. The information from her is set forth in a March 1946 letter from Frederick Stern, the New York art dealer who had been retained by the Gutmann estate to help locate Gutmann's missing works of art, to Dr. Scheller, the Dutch administrator of the Gutmann estate. Stern reported on his meetings with several firms in Paris, including the following:

Wacker-Bondy 236 Boulevard Respaille [*sic*]

Mrs. Wacker-Bondy gave me the following valuable information:

She was hiding in her apartment for the firm Graupe & Co. amongst other goods the following objects belonging to Mr. F. B. Gutmann:

1. 5 armchairs Louis XV with petite points. (List Arthur Goldschmidt No. 1 Item 2)

2. 1 painting small, portrait of a man by Dosso Dossi (list No. 2 item 5)

3. 1 painting large, the baptism of Christ school of Signorelli (list No. 2 item 12)

Those goods were seized in April 1943 by Dr. Lose [*sic*] of the Einsatzstab Rosenberg — headquarters Baron v. Behr 54 Avenue Jena Paris — as belonging to a Jew, taken away, without giving a receipt.

Mrs. Wacker-Bondy informs me further that Mr. Graupe's son — his name is now Mr. Grange and he is still a lieutenant in the British Army — has been recently in Paris; she gave him files and negatives from the firm Graupe which she was still hiding, and he gave them to his attorney maitre Fischer 177 Faubourg Poissonniere.[22]

Wacker-Bondy's list of objects owned by Gutmann and seized by the ERR includes two works of art, the Dosso Dossi (item 5) and the Signorelli (item 12), that were on Arthur Goldschmidt's list of works owned by Friedrich Gutmann and sent to Wacker-Bondy under the fictitious name Muir. Wacker-Bondy did not list as being seized by the Nazis Gutmann's Renoir and two works by Degas that were also on Goldschmidt's list.

The Nazi ERR documented what it seized from Wacker-Bondy in October 1942. The ERR's description of seized works translates as follows:[23]

Muir 1. Degas. *Nude Woman in an Armchair* before a hearth, being combed by a maid
H. G. Muir 2. Dutch 17th century, *Halt at an Inn;*
Muir 3. François Clouet, *Portrait of a Man with a Cap;*
Muir 4. Italian, Signorelli Workshop, *Baptism of Christ;*
Muir 5. Barbault, *Spanish Woman;* and
H. G. Muir 6. Dosso Dossi, Bust portrait of a young man in profile.

Each of the six works seized by the ERR was on Thomas Grange's list of forty-seven pieces sent by Paul Graupe & Co. to Wacker-Bondy. The ERR record shows that Muir 1, which is Gutmann's Degas known as *Woman Warming Herself,* was to "remain in Paris as 'modern,' designated for exchange," a common practice of the ERR for seized modern art. Muir 2 (not owned by Gutmann) and Muir 6 (Gutmann's

Dosso Dossi) were sent to Germany for the collection of Hermann Goe-ring (whose initials "H.G." appear on the ERR document).[24]

The ERR records correspond in part with Wacker-Bondy's report to Stern. There is a discrepancy as to the date of seizure—Mrs. Wacker-Bondy told Stern April 1943, whereas the ERR record shows seizure in October 1942, a date that is consistent with German shipping records showing that the Dosso Dossi was sent to Goering later in 1942.[25] And why did Wacker-Bondy not report to Stern that Gutmann's Degas *Woman Warming Herself* had been seized when ERR records explic-itly show that seizure (Muir 1)? Perhaps Wacker-Bondy did not know that *Woman Warming Herself* was owned by Gutmann. When Wacker-Bondy told Stern that works of art deposited by Paul Graupe & Co. were seized by the ERR "as belonging to a Jew," the reference was presumably not to Gutmann but to Paul Graupe, also "a Jew," given that the ERR seizure of the Graupe & Co. deposit under the name Muir included works not owned by Gutmann.

The Wacker-Bondy report and the ERR records do not provide the basis for a conclusion that *Landscape with Smokestacks* was stolen by the Nazis. Moreover, when the ERR did seize a work of art, the ERR would place its mark on the back.[26] Labels and markings on the back of *Landscape with Smokestacks* indicate sales and exhibitions, but none of the labels customarily employed by the ERR appears.[27] After a postwar search, an agency of the German government stated in 1960 that its documents "contain no indication that [*Landscape with Smokestacks*] was in the possession of the ERR."[28]

The six Muir pieces that were seized by the ERR were taken to the Jeu de Paume, the ERR collection place, where they were inventoried before they were either sent to Germany or, in the case of the Degas *Woman Warming Herself*, held for exchange.[29] The Jeu de Paume was where Rose Valland was initially believed by the Goodmans to have obtained photographs of Gutmann's three Impressionist works, thereby proving that the ERR had seized all three pieces. Nick Good-man testified in his deposition about his "understanding that Rose Valland took the photographs during the course of the Second World War while the paintings were at the Jeu de Paume where they had been placed by the German Army."[30] But it was not until after the war ended that Rose Valland came into possession of prints (not negatives)

of photographs of Gutmann's three Impressionist works. They had been sent to her organization, headed by Charles Dreyfus, by Thomas Grange in August 1946, along with his list of missing artwork.[31]

It is a common practice of art dealers to take photographs for their records and to distribute photographs of works to prospective buyers.[32] There is a caption, "No. 35 *Femme en chauffant* [*Woman Warming Herself*]," on the photograph of that Degas work. This is the caption on the same photograph of that piece that was number 35 in the catalog of the June 1939 exhibition at the Galerie Andre Weil in Paris.

The documents confirm that one of Friedrich Gutmann's works by Degas, *Woman Warming Herself*, was stolen by the Nazi ERR and taken to the Jeu de Paume. There is no documentation that his other Degas, *Landscape with Smokestacks*, met the same fate.

SOLD?

In the absence of evidence that *Landscape with Smokestacks* was stolen by the Nazis, what evidence is there that the landscape was sold?

In 1947, the Dutch administrator of the Friedrich Gutmann estate filed with the Dutch government many "Internal Notification Forms," each describing a particular work of art that had belonged to Gutmann. The forms for the Degas landscape and the Renoir show the words *vrijwillige verkoop* (voluntary sale). In contrast, the designation "voluntary sale" is stricken from the form for the Degas *Woman Warming Herself* (which ERR records show was confiscated by the ERR).[33] In 1991, Lili Gutmann sought the assistance of the Dutch government to recover the landscape. An official of the Netherlands Office for Fine Arts replied: "According to the statement on the Notification Forms, the matter involved a 'voluntary sale.'"[34]

In the immediate aftermath of World War II, the French government undertook to assist in the recovery of missing art. Without making any findings about whether a particular work had been stolen or was otherwise missing, the French Commission de Récupération Artistique collected in a central list all the objects of art that prior owners claimed were missing. This compilation was under the direction of Charles Dreyfus.

Among the August 1946 lists of missing paintings, art objects, furniture, and silver that Paul Graupe's son, Thomas Grange, sent to Charles Dreyfus, the director of the French commission in charge of the recovery of missing art, was "2A) List of old masters that belonged to the firm of GRAUPE & Co. and put on deposit at the firm of Mme. WACKER-BONDY, 236 Boulevard Raspail, removed by the Germans." That list included Gutmann's two works by Degas, *Landscape with Smokestacks* and *Woman Warming Herself,* and his Renoir. Grange prefaced list 2A with the statement "It is possible that some of these paintings were no longer located at Mme. Wacker-Bondy's when the Germans arrived. In that case, I will send a corrective list."[35]

In December 1946, Grange, as promised, sent to Dreyfus a corrected list of the works that were no longer located at Wacker-Bondy's when the Germans arrived. The translation of Grange's December 1946 letter is as follows:

Dear Mr. Dreyfus:

I currently find myself in New York where I came to spend Christmas with my father, and on this occasion I was able to discuss with him all of the paintings which were either in his possession in his office at 16 Place Vendôme, or stored at Mme. Wacker-Bondy, 236 Blvd. Raspail, and which had been stolen by the Germans. We reviewed together all of the photographs which were located in the files which we just received from Paris after months of waiting. I also have spoken with Mr. Frederic Stern, of 230 Central Park West, New York, who is the designated administrator for the probate proceeding of Mr. F. Gutmann, Heemstede, Holland, many of whose paintings were in my father's custody.

As a result, we discovered that the lists which Mr. Stern and I have submitted included some of the same stolen pictures for until now neither of us had any knowledge of the other's list. To make things easy for you, I would like to submit to you the list of pictures which you can delete from my claim because they are also found on Mr. Stern's list. I am also attaching the pictures to be deleted from my claim which my father had sold, without my knowledge, just before the war, a fact he had been unable to recall until now, when we received our files from Paris. I apologize for having inconve-

nienced you in this way with a correction, but I believe that a correction is preferable to an error.

I have also been able to obtain new pictures of our stolen paintings which I will have transmitted to you as soon as possible to facilitate your investigations. I will also try to come as soon as possible to see if I can now identify the objects which have been located.

Attached is the list of objects to delete from my claim since they are on Mr. Stern's list or were legally sold.[36]

Landscape with Smokestacks is included in the "list of objects to delete," which, according to Grange, means that the landscape either was "on Mr. Stern's list or [was] legally sold."

The attachment to Grange's December 1946 letter deleted *Landscape with Smokestacks* but did not delete Gutmann's *Woman Warming Herself.* This is consistent with the landscape's having been legally sold, whereas, as is known from the ERR document, *Woman Warming Herself* was stolen by the ERR. The other possibility is that the landscape was deleted because it was on the list of missing Gutmann works that Stern had sent to Dreyfus. But is it likely that Stern would have listed the landscape as missing without listing Gutmann's other Degas? If Stern's list included both works by Degas, Grange would have deleted both in his corrected list.

Stern had been told by Goldschmidt's November 1945 letter to Stern's lawyer Simon that both of Gutmann's works by Degas had been transferred to Wacker-Bondy in 1940, and Stern's report of his meeting with Wacker-Bondy cited Goldschmidt's list with respect to two other Gutmann pieces. Nevertheless, the lists of Gutmann works of art prepared by Stern made no mention of Gutmann's two works by Degas.

In March 1946, Stern prepared a long list of missing Gutmann works of art for Dr. J. R. R. Scheller, the Dutch administrator of the Gutmann estate.[37] Neither Gutmann's *Landscape with Smokestacks* nor his *Woman Warming Herself* was on that list. Nor were the landscape and *Woman Warming Herself* listed on any document produced by the Goodmans that could be identified as a list sent by Stern to Dreyfus of the French commission. In August 1946, the same month that Grange's list was sent to Dreyfus, Scheller sent a letter to Drey-

fus asking that Wacker-Bondy be permitted access to the Jeu de Paume

to see if she can locate among the recovered art works the ones that were removed from her premises.

The matter concerns:

1. Five Louis XV armchairs
2. A painting—small portrait of a Man by Dosso Dossi
3. A painting *The Baptism of Christ*, school of Signorelli[38]

Again no mention of either of Gutmann's works by Degas.

In the absence of any list from Stern to Dreyfus that included *Landscape with Smokestacks*, Grange's deletion of the landscape from his prior list means that he had concluded that the landscape had been legally sold.

One curiosity in Grange's December 1946 letter from New York is his reference to pictures that his father had sold "just before the war." Perhaps, writing from New York, Grange regarded any time before the entry of the United States into the war in December 1941 as before the war. In any event, it is clear that a number of the works of art deleted as legally sold were sold after World War II began in Europe. For example, six of Gutmann's pieces transferred to Wacker-Bondy after the German occupation of France in 1940 were removed upon their sale to Haberstock in 1941 and were on Grange's corrected list of works to be deleted.

If Grange's December 1946 report can be relied upon, he and his father, Paul Graupe, to whom Friedrich Gutmann sent *Landscape with Smokestacks* in April 1939, reviewed the files of the Graupe firm and concluded that *Landscape with Smokestacks* had been legally sold. But is Grange's report reliable? Grange's treatment of Gutmann's Renoir casts doubt. Although Grange's corrected list deleted *Landscape with Smokestacks*, it did not delete the Renoir. This would mean that the Renoir was neither on Stern's list nor legally sold. What happened to the Renoir? There is no record that the ERR stole it from Wacker-Bondy's.

Access to the files of Paul Graupe & Co. that Grange and his father reviewed in December 1946 might resolve any ambiguities. Counsel for Searle retained an investigator in London to seek access to those

files, which presumably had come into the possession of Grange, also an art dealer, upon the death of his father. It was determined that Grange had died in 1978. Efforts to locate the files through Grange's widow were unsuccessful.

On the hypothesis that Paul Graupe did sell *Landscape with Smokestacks,* to whom did he sell it? Presumably to Hans Wendland, the next name on the landscape's provenance.

Paul Graupe and Hans Wendland had known each other for a long time, at least as far back as 1933, when Graupe had auctioned part of Wendland's collection in Berlin.[39] When World War II began, both Graupe and Wendland were living at the Hotel Plaza Athénée in Paris.[40] Graupe and Wendland jointly owned several works of art, two of which were listed by Graupe's son, Grange, as having been part of the Muir storage group at Wacker-Bondy[41] and were later sold.[42] Wendland also stored some of his own works of art at Wacker-Bondy.[43]

Given the numerous dealings in art between Graupe and Wendland, Hans Wendland may have acquired *Landscape with Smokestacks* from Paul Graupe, to whom Friedrich Gutmann had sent the landscape on consignment.

On this hypothesis, how did the landscape get to Switzerland? Paul Graupe fled Paris for New York in December 1940, traveling by way of Geneva, Switzerland, and Lisbon, Portugal. Graupe took artworks from Paris to Geneva, where he "saw Wendland frequently," and, before leaving Geneva, left at least three pieces with Wendland. It is also possible that Wendland acquired the landscape from Graupe in Paris after the German occupation in June 1940. Wendland had lived in Paris until "the outbreak of war," when "Wendland had his furniture and library sent from Paris to Geneva."[44]

The available documents do not include a bill of sale or other documentation of a sale of the landscape. Any transfer by Graupe on behalf of Gutmann would presumably have been in cash, because the documents indicate Gutmann's desire to be paid in cash for his works of art.[45] The lack of a record of such a transaction is not surprising given Wendland's informal handling of works of little value[46] and the relatively low value of *Landscape with Smokestacks* at that time. In 1964, Sotheby's, London, opined on the probable market value of Gutmann's

three Impressionist pieces (based on photographs) and concluded that the landscape was the least valuable of the three, having only about one-fifth the value of the Degas *Woman Warming Herself*.[47]

There is not any record of how much, if any, consideration Graupe received if he sold the landscape to Wendland or whether any money reached Friedrich Gutmann. If Paul Graupe had any concern about owing money to Gutmann's heirs, it was against his pecuniary interest to have the 1946 corrective list sent to the French authorities identifying the landscape as having been legally sold rather than seized by the Nazis. But even if Graupe did not receive consideration from Wendland, or if Graupe received payment but failed to remit the money to Gutmann, Wendland would have received good title to the landscape, and subsequent purchasers from Wendland would also obtain good title. Gutmann sent the landscape to Graupe on consignment, which authorized Graupe to convey title. Under the practice and custom of the art trade,[48] consistent with the laws of France (and the United States as well), Friedrich Gutmann's claim as consignor would be against consignee Paul Graupe & Co. Gutmann would not have a claim against Wendland or a subsequent purchaser from Wendland even if, as a custodian, Graupe had not been authorized to sell the landscape. This was explained by Professor Arthur T. von Mehren of Harvard University, the expert on foreign law retained by the Goodmans: "[I]n cases in which a custodian (such as Graupe or Wacker-Bondy) sells the chattel [such as a painting] to a third party without authority from the true owner [Friedrich Gutmann], French law does not regard the chattel as 'lost' or 'stolen' for the purposes of Article 2279, but instead treats the matter as a breach of trust by the custodian. Accordingly, in such cases, French law generally precludes the true owner from recovering the chattel from a good faith purchaser and limits the true owner to a claim for damages against the custodian."[49]

The next name after Wendland in the landscape's provenance is Hans Fankhauser of Basel, Switzerland. A 1966 obituary described Fankhauser as "a Basel silk merchant" who was an "ardent devotee of the arts" with "far-reaching connections with art historians and art dealers."[50] Wendland was previously married to Fankhauser's sister[51] and, at the end of World War II, was deeply in debt to Fankhauser.[52]

There is no bill of sale or other document directly identifying *Landscape with Smokestacks* as sold by Wendland to Fankhauser. Documents do show that Wendland transferred a number of artworks to Fankhauser in partial satisfaction of his indebtedness.[53] One document refers to 1946 sales by Wendland of "miscellaneous art objects" purchased by "F. Fankhauser."[54] Given its relatively low value, the Degas landscape may have been one of those miscellaneous art objects. Whatever the documentation of Wendland's sale, Emile Wolf was told that Fankhauser had bought the landscape from "Hans Wendland Paris."

HANS WENDLAND, RED FLAG OF NAZI LOOTING?

An essential element of the Goodmans' version of what happened to *Landscape with Smokestacks* is that the name Hans Wendland in the provenance was a red flag because Wendland was "one of the worst of the known profiteers from the Nazis . . . from looted Jewish property." The press and television reports quoted Willi Korte, who proclaimed that, with the name Hans Wendland on the provenance, "there was only one association you could draw with that name . . . and that is that it's a plundered work of art."

The only documentary authority cited in this vilification of Wendland was the report of a 1946 interview of Wendland by the Strategic Services Unit of the United States War Department.[55] That document, entitled "Detailed Investigative Report" and dated September 18, 1946, describes an interview with the then sixty-six-year-old Wendland conducted over an eleven-day period by two United States Army officers.[56]

The introduction to the report states that Wendland "figured, whether wittingly or not" in the receiving of confiscated art and the importation of that art into Switzerland.[57] Wendland admitted that he participated in exchanges of modern pictures owned by Goering for old masters and that he suggested to Goering the use of diplomatic pouches to expedite shipments of art from Germany to Switzerland, where the works could be sold to obtain Swiss francs, a hard currency more useful to Goering during the war than French francs or German marks.[58] Wendland repeatedly denied having had any knowledge that

the art he dealt with had been confiscated by the Nazis.[59] Wendland claimed that he was Jewish and that he brought works of art owned by other Jewish dealers (including Paul Graupe) from France to Switzerland to protect them from seizure by the Nazis.[60]

Wendland told the interrogators that he had at one time had a sizable fortune but that his assets had dwindled down to a few objects of art and that he had incurred considerable debt.[61] The investigative report lists various locations in Switzerland and France where Wendland said his remaining works of art were located. The list for Switzerland covered well over a hundred pieces located in warehouses and with friends, one of whom was believed to be "Fritz Fankhauser, Basle [*sic*]."[62]

The Army interrogators were, to say the least, skeptical of Wendland's story. Their report concludes with the following summary:

WENDLAND cannot be considered to have been a guiding spirit in the main art looting activities of the times, but he was one of those who were eager to profit from these activities. The exact degree of his culpability in the events in which he figured is difficult to determine. The lack of access to his records concealed in Switzerland and elsewhere and his convenient as well as chronic bad memory, made it well-nigh impossible to pin him down to any exact or definite assertions. During the interrogations he may be said to have proved willing to talk but reluctant to communicate. During the great catastrophe of World War II, WENDLAND — as he has all of his life been able to do — not only avoided the sufferings and misfortunes that most of the rest of the world was undergoing, but was able to make financial capital of them. It is recommended that he be retained in custody until such time as conclusive investigations may be made in Switzerland and France, the full extent and nature of his assets revealed, and the disposition of these assets determined.[63]

In 1946, the United States Office of Strategic Services issued a report listing hundreds of persons said to have participated in "the art trade under the Nazis" with a brief description of each.[64] The listing for Dr. Hans Wendland has the following description: "Probably the most important individual engaged in quasi-official looted art transactions in France, Germany and Switzerland in World War II. Acted

as intermediary between Hofer and Fischer, and as Fischer's chief purchasing agent. . . . Has never sold works of art directly to private purchasers; always working as dealers' expert and agent. His activities presently under close scrutiny by the Swiss government."[65] Walter Andreas Hofer was described in the report as "Goering's chief purchasing agent."[66] Theodor Fischer was described as "the focal point in all looted art transactions in Switzerland, and recipient of the greatest number of looted paintings located to date."[67] The report also described Karl Haberstock, with whom Friedrich Gutmann had personally negotiated a sale of art, as "Hitler's dealer" and "the most prolific German buyer in Paris during the war and regarded in all quarters as the most important German art figure."[68]

Nothing came of the Swiss government's investigation of Wendland, but the French pursued the matter. The Strategic Services' investigative report on Wendland was sent to the French government.[69]

Wendland was put on trial in Paris in February 1950. The trial was before a military tribunal that consisted of seven members, five of whom, as required by French law, had been officers in French resistance organizations during the war.[70] Wendland was charged with *complicité de pillages* (complicity in looting).[71]

The French prosecutor accused Wendland of looting and presented witnesses who testified that Wendland had bought works of art in France that he turned over to the art dealer Hofer, described as "Goering's official buyer."[72] Wendland's defense to the charge of looting was summarized by his lawyer as follows: "My client is guilty of nothing of the kind; he contented himself with buying paintings that various Frenchmen were perfectly willing to sell to him. These were mutually agreeable commercial transactions without any compulsion."[73]

In entering its *jugement,* the military judges made three findings:

FIRST QUESTION

Is it established that between 1941 and 1944, in any event at times within the period of limitations, subsequent to the commencement of hostilities, in France, a certain number of works of art were removed or exported from French territory?

The military tribunal's answer to the first question was *oui.*

Second Question

Were the acts set forth above, though carried out during the existence of, and purportedly motivated by, a state of war, justified by the laws and customs of war?

The military tribunal's answer to the second question was *non*.

Third Question

Is the defendant WENDLAND, Hans, art expert, domiciled at 35 Rue de Cambon, Paris 1, a civilian of German citizenship, guilty, while in the enemy's administrative service, of having knowingly aided or assisted, at such times and places, the perpetrators of acts which prepared, facilitated or consummated the violation specified in the 1st and 2d Questions?

The military tribunal's answer to the third question was *non*.

The military tribunal's *jugement* concluded:

> Wherefore, the Court *ACQUITS* the above-described defendant WENDLAND, Hans, of the charge brought against him.[74]

A Paris newspaper reported that the military tribunal acquitted Hans Wendland "[a]fter a quarter of an hour of deliberation."[75]

A finding of not guilty does not mean that Hans Wendland was innocent of complicity in Nazi looting of art. The United States Army interrogators did not believe Wendland's protestations of innocence in 1946. And the French government prosecutors believed they had evidence of Wendland's guilt at the 1950 trial. One would have expected that a military tribunal consisting mainly of officers of the French resistance would have taken a jaundiced view of Wendland's innocence. Perhaps the finding of not guilty in 1950 resulted from the tribunal's view that the evidence at the trial relating to events five to ten years earlier was inadequate. Perhaps there was some sympathy for the no longer wealthy, then seventy-year-old Wendland.

Lynn Nicholas, in her 1994 book *The Rape of Europa*, implicated Hans Wendland in knowingly dealing in art stolen by the Nazis without mentioning that he had been charged but acquitted. Retained by the Goodmans as a witness, Nicholas questioned whether the French military tribunal was correct in its acquittal of Wendland. At the same

time, Nicholas conceded at her deposition that Wendland might have been "involved in legitimate art dealings," citing documents showing that Wendland "owned pictures with Graupe."[76] On her premise that Wendland was guilty of complicity in stolen art but also engaged in legitimate art dealings, Nicholas left open the possibility that Wendland acquired *Landscape with Smokestacks* legitimately from Paul Graupe.

In contrast, Willi Korte's repeated assertions that the only conclusion that could be drawn from Wendland's possession of the landscape was "that it's a plundered work of art" were absolute. In making such categorical assertions, Korte included no mention of the not guilty finding of the military tribunal, which he should have known about. The press report of the acquittal was one of the documents produced by the law firm representing the Goodmans,[77] with which Korte worked as a "researcher-expert on the records."[78]

Thanks to Nicholas's 1994 book and particularly Korte's accusations beginning in 1996, the name Wendland is now widely known in art circles. That was not so in 1987, when Searle bought the landscape. At that time, the curators at the Art Institute had never heard of Wendland.[79] Margo Schab, the dealer through whom Searle bought the work, had never heard of him.[80] After Korte asserted Wendland's guilt of complicity in Nazi thefts, Schab checked with ten other dealers in French Impressionist art and not one had ever heard of Wendland.[81] When Lili Gutmann was asked when she first heard of Hans Wendland, she replied, "1995."[82]

If the curators at the Art Institute or Schab had heard of Wendland in 1987 and investigated him before Searle bought the landscape, they would have learned that Wendland was a shady, elusive character who had been tried on the charge of complicity in Nazi looting and found not guilty.

Chapter Six

The Postwar Search

W HEN Germany surrendered in May 1945, Lili Gutmann was in Italy, separated from her husband, who had been an officer in the Italian army.[1] Her brother, Bernard, who had changed his name to Goodman, was in England, discharged from the British army and working for the British Red Cross.[2] Each was concerned about the fate of their father's valuable art collection.

1945 TO 1960

In May 1945, Lili Gutmann, while in Rome, sent a letter to the Allied Commission of Fine Arts listing works of art she believed had been in her father's house in Holland at the time of the Nazi occupation. Her list did not include her father's two works by Degas, the Renoir, or the other pieces that had been sent to New York and Paris according to the note she had received from her father in 1942.[3]

In the summer of 1945, Bernard Goodman, from London, sent a list of artworks to the Dutch agency responsible for the recovery of missing art. Bernard stated that he was listing pieces that belonged to his late father "and which under pressure of a German art dealer he was compelled to sell." The list included his father's three Impressionist works, the six works sold to Karl Haberstock out of the Wacker-Bondy storage place, and other pieces.[4] There is no explanation of the source of Bernard's information about those works of art or what led him to assert that the three Impressionist works had been sold to a German art dealer, presumably Haberstock, who had no interest in acquiring Impressionist art. Bernard's report did not mention seizure of any of the pieces by the ERR.

Lili and Bernard were not able to get together in Holland until 1946. Lili was delayed because, living in Italy and traveling on an

Italian passport, she was regarded as an enemy by the Dutch government.[5]

When Lili and Bernard finally got together in Holland, they found that their father's estate was deeply in debt and that the mansion had been heavily mortgaged. Stripped of all its art, furniture, carpets, and mirrors, the mansion was occupied by nuns running a home for ailing Catholic children.[6] To complicate matters, a Nazi administrator had taken over Friedrich Gutmann's business, had liquidated its assets, and had run off with the proceeds and most of its records.[7]

Meanwhile, the Dutch government had appointed J. R. R. Scheller as the administrator of the Friedrich Gutmann estate. Scheller began investigating the whereabouts of Friedrich Gutmann's property, including his art collection. In late 1945, Scheller and a Dutch official traveled to Munich, which was one of the largest collection points of looted art. In Munich, Scheller identified several works of art belonging to the Friedrich Gutmann collection, one of which was the Signorelli piece that the ERR had seized from Wacker-Bondy.[8] At a collection point in Amsterdam, he found much of the Gutmann family's furniture and other household items.[9]

Scheller found that Friedrich Gutmann had, on three occasions, sold artworks and other valuables to the German art dealer Karl Haberstock. One was the 1941 sale of six works that had been stored at Wacker-Bondy in Paris. In 1942, Gutmann had made two sales to Haberstock (jointly with a Munich art dealer). The proceeds of those sales had gone to reduce Gutmann's debt.[10]

The works of art that had been sold to Haberstock and his partner were claimed by the Dutch government. The Allied governments, in establishing procedures for the recovery of missing art, agreed that works of art found in Germany, whether plundered or purported to have been voluntarily sold, would be returned to the governments of the countries from which they had been taken, not to individual owners.[11] Under Dutch law, in cases of voluntary sales to Germans during the war, ownership of the transferred artworks was lodged with the Dutch government.[12] Lili and Bernard recovered the pieces that had been sold to Haberstock, but only after paying the Dutch government a price agreed upon after years of dispute.[13] Works that Friedrich Gutmann had not sold but had been seized by the Nazis and then recov-

ered were returned to Lili and Bernard without any payment to the Dutch government.[14]

It was not until the mid-1950s that the Friedrich Gutmann estate was settled. By that time, most of Gutmann's art collection had been accounted for. Artworks and other objects that had been recovered were sold to pay off Friedrich Gutmann's debts.[15] Eleven of Gutmann's pieces, including his three Impressionist works, were still missing.

In searching for the missing works of art, Lili Gutmann sought the advice of the director of an Amsterdam art museum, who told her that if the works could not be found in western Europe, there were three possibilities: "[T]hey could have been destroyed during the war. They could have been picked up by an American G.I., but most probably they are finished [sic] in Russia."[16]

Lili spoke to other museum directors and art dealers in her search for her father's missing artwork. Those discussions led her to Rose Valland, who was asked to help in the search for Friedrich Gutmann's missing art, including the three Impressionist works that had been sent to Paris in 1939.[17] Valland provided Lili and Bernard with copies of the photographs of the three works.[18] Valland had gained access to the photographs when Thomas Grange sent his list of missing works of art and their pictures to the head of her agency, Charles Dreyfus. Valland was helpful to Bernard and Lili in recovering some of Gutmann's missing pieces, but the three Impressionist works remained missing.[19]

In 1956, Bernard Goodman wrote to Britain's Scotland Yard, providing Interpol with a list of artworks that "belonged to my late father Mr. F. B. E. Gutmann of Heemstede, Holland," that were "deposited by my father before the war with the Paris art-firm of Paul Graupe . . . from whose premises they dispapeared [sic] presumably stolen."[20] The list included Gutmann's Renoir, *Landscape with Smokestacks*, and the Degas *Woman Warming Herself*.

During the mid-1950s, the relationship between Bernard and Lili was troubled. Bernard was incensed that Lili had gained possession of their mother's jewels and kept the proceeds of their sale for herself. Bernard sued Lili and, after a "long and costly wrangle," settled for less than the half-share he had sought.[21] Bernard also accused Lili of gaining possession of two of their father's works by Guardi, selling

them, and keeping the proceeds for herself.[22] At the same time, Bernard requested an art dealer in New York not to tell Lili about his sale of their father's piece by Hans Baldung Grien.[23] Lili acknowledged that "we had trouble in those years" and that it "took quite a few years to work things out."[24]

THE GERMAN COMPENSATION PROCEEDING, 1961 TO 1967

In August 1961, the German Federal Service issued a formal finding terminating attempts to recover Friedrich Gutmann's Dosso Dossi and his three Impressionist works because they could not be located in Germany and "further investigations [held] no prospect of success."[25] This finding served as the predicate for an owner of artwork seized by the ERR to petition Germany for compensation.

Bernard Goodman and Lili Gutmann retained a lawyer, F. Mannheimer of Amsterdam, to seek compensation from the German government for the loss of their father's missing art. In April 1960, Lili Gutmann wrote to Mannheimer providing background information about her parents. Gutmann attached a list of eleven "unreturned paintings from the collection of F. Gutmann." The list included the Dosso Dossi *Portrait of a Man*, the Renoir, and the two works by Degas. Each of the three Impressionist works was described, along with a reference to the number of its Dutch notification form. Lili suggested that Mannheimer "make use . . . of the notification forms that were filed at the time with the [Dutch government]."[26]

To obtain compensation from Germany for Gutmann's missing works of art, Mannheimer was obliged to establish that the pieces had been stolen and taken into Germany. Mannheimer elicited the aid of Rose Valland, who had worked in the Jeu de Paume when the ERR was using that museum as the collection point for art stolen by the ERR. After the war, Valland was employed by the French government as a conservator of national museums. A letter written by Valland to Mannheimer in April 1964 became the sole basis for the Gutmann/Goodman claim for compensation from Germany for *Landscape with Smokestacks*. That Valland letter would also become the centerpiece of their claim against Searle.

In April 1964, Mannheimer sent to the German government a formal application for compensation for Gutmann's missing art, including the Dosso Dossi, the Renoir, and the two works by Degas. Mannheimer stated: "The fact that these paintings were taken can be definitely established, but it was hitherto not possible to prove their passage into Germany." As proof, Mannheimer submitted a letter dated earlier in April from the "Conservator of National Museums and Head of the Service for the Protection of Works of Art," who was Rose Valland.[27]

Mannheimer elicited this letter by writing to Valland in March 1964, introducing himself as the lawyer for Bernard Goodman and Lili Gutmann, and stating that he was "trying to obtain an indemnification from the German authorities, because the paintings were confiscated by their National-Socialist predecessors as Jewish property." Mannheimer listed the pieces, including the Dosso Dossi, the Renoir, and the two works by Degas, as well as a Van Goyen and a Van der Velde, and told Valland that

> Mr. Gutmann had sent these paintings to Paris as a security measure. All these paintings had been deposited at the Wacker-Bondy shipping company, 236 Boulevard Raspail, by the Graupe firm, Place Vendôme, Paris.
>
> From there the paintings were confiscated by the National-Socialist German authorities and taken away to an undisclosed location.
>
> It is because of these facts that I take the liberty of asking your advice as to what agency I should approach in order to obtain:
>
> 1. evidence of the fact that these paintings were confiscated by the Germans at the Wacker-Bondy Company;
>
> 2. a confirmation I can use to prove where the paintings were sent.
>
> According to current German law the grant of indemnification depends on proof that properties taken by the Germans during the Occupation were sent to West Germany or the city of Berlin.
>
> I would be most grateful if as a result of your great experience you could advise me in this area.[28]

In her April 1964 letter to Mannheimer, Valland responded as follows:

Counsel:

I am happy to provide you with the information at my disposal concerning the paintings referred to in your letter of March 31, 1964.

On the list of properties deposited by Monsieur Graupe with Madame Wacker-Bondy the [following] paintings indeed appear:

Renoir: *Apple Tree* (or *Pear Trees in Bloom*)
Degas: *Pastel, Small Landscape*
Woman Warming Herself
Dosso Dossi: *Small Portrait of a Man*
Van Goyen: *Landscape*

On the other hand, I was not able to identify the Van der Velde on this list.

According to the statement of Madame Wacker-Bondy and the inquiry that has been conducted, on the part of the Dutch as well as the French, there is no doubt that this store of paintings was seized by a member of the Einsatzstab Rosenberg. This is confirmed by the fact that a certain number of these paintings are recorded on the inventory of the Einsatzstab under the acronym MUIR (the name under which Monsieur Graupe had made the deposit at Madame Wacker-Bondy's).

Thus: MUIR 1 — Degas, *Woman Warming Herself*

MUIR 6 — Dosso Dossi

Other paintings from the same store (MUIR 3-4-5: Clouet, Spanish painting[,] Signorelli) have been found in Bavaria, in storage at Füssen, and returned as you are perhaps aware.

It is known, further, that the small portrait by Dosso Dossi entered the collection of RM. Goering on November 25, 1942, as No. 1284.

The Federal Service for External Restitutions of Bad Homburg has moreover admitted the legitimacy of the restitution claims covering the first four paintings on your list, which reflects its recognition of their seizure by an official National Socialist organization and their conveyance to Germany.

Since the conduct of further investigations in Germany had no chance of success, the Federal Service decided on August 5, 1961, to terminate the restitution proceeding with respect to the first four paintings.

As far as the Van der Velde is concerned, the only actual mention

in our files is a note in Dutch (copy attached) which, as far as I can determine, does not allow one to conclude that this painting was looted in France.

The Van Goyen was considered by my agency as having been returned, as the result of the return of a painting by this painter which was carried out through our efforts for the benefit of Madame Lili Gutmann. According to your description, however, the question might involve a completely different painting, a matter on which I can shed no light.

I add in this regard that cross-checking among pieces of information that are confused and frequently contradictory (as a result of the events of the war), provided by various interested parties, and the further fact that we have never been informed in a timely fashion about returns made directly to Holland for the benefit of the Gutmann estate, even as to properties looted in France, has in many cases made our task of identification and clarification almost impossible.

Finally, I think I can assure you that the position taken by the Federal Service in its termination decision of August 5, 1961 with respect to the paintings of the Gutmann estate is sufficient to justify the indemnification claim which you are submitting in its name to the German reparation agencies.[29]

Valland cited the German Federal Service as having recognized that Gutmann's Dosso Dossi and three Impressionist works had been seized by the Nazis and conveyed to Germany.[30] That is not what the German Federal Service concluded. Valland correctly stated that the Federal Service decided in August 1961 to terminate the restitution claim for Gutmann's Impressionist works. This was not a conclusion that they had been seized by the ERR but a conclusion that Germany could not return the works to Gutmann "since the conduct of further investigations in Germany [held] no prospect of success."[31] If the German Federal Service had made a finding that Gutmann's works of art had been stolen by the ERR and conveyed to Germany, it would not have been necessary for Mannheimer to rely on the Rose Valland letter to obtain compensation for the missing pieces.

Mannheimer wrote to Valland again in June 1964, thanking her for her April letter "which has helped me greatly" and making a further request: "Would it be possible for you to send me a copy of Madame

Wacker-Bondy's statement mentioned in your letter? This statement would be extremely useful to me in bolstering my proof and would give me in addition a more detailed view concerning all Mr. Gutmann's items deposited with her."[32]

Mannheimer also noted that he had recently received a copy of a statement from Frederic A. Stern that there were, in addition to paintings, Louis XV armchairs and other objects "which were also hidden at Madame Wacker-Bondy's." (This is the letter in which Stern reported that Wacker-Bondy had told him that the ERR had seized Gutmann's works by Dosso Dossi and Signorelli.)

Valland responded to Mannheimer's further request for "a copy of Madame Wacker-Bondy's statement mentioned in your letter" as follows: "As far as the statement of Madame Wacker-Bondy, which I mentioned in my letter of 7 April, is concerned, I can specify that this statement was made by this lady to Dr. J. R. R. Scheller, of Amsterdam, who from the beginning has been involved, among other people, as judicial administrator for the recovery of the property of Mr. F. Gutmann and who communicated this information to the French services by letter of August 17, 1946."[33]

Scheller's August 1946 letter to the French services, relied upon by Valland as the source of her information about Wacker-Bondy, referred only to Gutmann's Dosso Dossi and Signorelli, with no mention of Gutmann's three Impressionist works.

What does the Rose Valland 1964 letter prove? Valland does not claim that she had any personal knowledge of what happened to *Landscape with Smokestacks* in 1942. Valland relies, first, on the fact that Gutmann's three Impressionist works and his Dosso Dossi were on the list of pieces Paul Graupe & Co. sent Wacker-Bondy and, second, on ERR records showing that the ERR seized Gutmann's Dosso Dossi and his Degas *Woman Warming Herself* from the Wacker-Bondy store. The Valland letter decisively supports the Gutmann/Goodman claim that those two works were stolen by the Nazis. But the Valland letter leaves open the question of whether Gutmann's Degas landscape had been removed from Wacker-Bondy before the ERR arrived there.

In the 1950s, Rose Valland had been helpful to Lili Gutmann in the search for her father's missing art, including the return to her of a

work by Van Goyen.[34] But in her effort to help Mannheimer in the Gutmann/Goodman claim for compensation from Germany, the most Valland could say with respect to *Landscape with Smokestacks* was that it and other works had been sent to Wacker-Bondy in 1940 and that in 1942 the ERR had seized from Wacker-Bondy "this store of paintings" (*ce dépôt de tableaux*).[35] Valland did not say that the ERR seized all the paintings for which Mannheimer sought compensation, but only that there had been an ERR seizure from "this store of paintings." Coupled with the ERR record showing that Gutmann's Dosso Dossi and his Degas *Woman Warming Herself* had been seized, Valland did not disclaim an inference that the ERR also seized *Landscape with Smokestacks*.

But it does not follow that because other works of art belonging to Gutmann were seized by the ERR from Wacker-Bondy, *Landscape with Smokestacks* was among those seized. The absence of any ERR record of seizure of that piece indicates that it was not taken by the ERR. The director of the German restitution agency stated, "From the fact that [works] do not appear in the inventory of Reichsleiter Rosenberg [ERR], it follows that the latter did not take them into his possession."[36] As Graupe's son Grange had established, many of the works of art deposited at Wacker-Bondy in 1940 were not there when the Germans arrived.

When Mannheimer presented the Valland letter to the German government, the translation of the French *ce dépôt de tableaux* into German was not the English equivalent of "this store of paintings" but the English equivalent of "these stored paintings" (*diese eingelagerten Gemälde*).[37] By listing *Landscape with Smokestacks* as one of the missing works of art and translating Valland's letter as saying that "these paintings" had been seized by the ERR, Mannheimer produced a translation saying that *Landscape with Smokestacks* had been seized, whereas Valland said only that the ERR had seized the Wacker-Bondy "store of paintings." ERR records showed that Gutmann's Dosso Dossi and Degas *Woman Warming Herself* had been seized from the Wacker-Bondy "store of paintings," not the Degas *Landscape with Smokestacks*.

In early 1965, Mannheimer was preparing for discussions in Berlin about the Gutmann/Goodman claim for compensation. By that time,

Lili Gutmann had given Arthur Goldschmidt's November 1945 letter to Mannheimer. The attorney was alarmed. In a March 1965 letter addressed to Bernard and Lili, Mannheimer stated:

> In the matter of the paintings I confirm with thanks receipt of the letter of Mr. Arthur Goldschmidt to Mr. Paul Simon of November 20, 1945, which was forwarded to me by Mrs. Gutmann.
>
> To make what follows clearer for you I enclose herewith a copy of the letter.
>
> For the moment I do not think the letter should be produced to the German authorities. The letter might cause the case to become somewhat confused.

After discussing other documents, Mannheimer continued:

> For the reasons stated I am not going to produce the foregoing documents, but will try to find out whether the agency has objections and, if so, what the objections are.
>
> I presume, however, that I will be asked for further proof that the paintings at the time of the seizure were really still the property of your father, and thus not the property of the Graupe firm or even of Haberstock.
>
> In order to answer this question I have some further questions for you:
>
> 1. Was Arthur Goldschmidt a partner of Graupe's? He writes: ". . . in our galleries at 16 Place Vendôme . . ." He writes further that the pictures were given to the Graupe firm on consignment. In fact, you never told me about giving on consignment, but only said that your father had caused the paintings to be taken to Paris because he thought they were more secure there.
>
> 2. Is this Arthur Goldschmidt still alive? In that case we should try to obtain a short statement from him whose only subject would be that the paintings were never purchased, but remained the property of your father, although they were also booked at Wacker-Bondy as a deposit from Graupe.
>
> I will advise you next week of the result of my trip to Berlin, and urge you most earnestly to start working on the things I asked you to address.[38]

No statement that "the paintings were never purchased, but remained the property of your father" was produced from Goldschmidt, or from

his partner Paul Graupe, or from Graupe's son Thomas Grange, who had access to the files of Paul Graupe & Co. and who was a friend of Bernard Goodman.[39] Lili Gutmann made no effort to obtain such a statement.[40]

At a 1965 meeting with counsel for the German government in Berlin, Mannheimer confined the Gutmann/Goodman claim for compensation to four items, the Dosso Dossi, the Renoir, and the two works by Degas. The claim that the works had been confiscated by the ERR was supported by three documents:[41]

1. A letter to Mannheimer from a German agency that discussed the Dosso Dossi but expressed regret that it was unable to supply information about the other pieces[42]

2. A letter to Mannheimer from a Dutch agency that advised that "no original records exist here concerning the fate of the pictures" and referred to the Rose Valland letter as its only information about Gutmann's three Impressionist works (Mannheimer characterized the information received from the Dutch agency as negative, "since that Institute has no data about paintings that were sent to other countries before the occupation of Holland")[43]

3. The Valland April 1964 letter itself

As a result, the sole basis for the claim for compensation for the loss of *Landscape with Smokestacks* was the Valland letter. There is no evidence that Mannheimer produced to the German government either the Goldschmidt/Simon letter or that he produced the Dutch Notification Forms about which he had been informed in Lili Gutmann's April 1960 letter. (These are the forms showing that Gutmann's Degas landscape and the Renoir had been "voluntarily sold.")

The German government proceeded to the next step in the compensation process, obtaining appraisals of the values of the four works of art. In February 1966, Mannheimer reported to Lili Gutmann on the status of the compensation proceeding, noting that it was to his clients' advantage to deal with the four pieces as a group rather than asking for separate examinations of the evidence for each.[44] Given that ERR records supplied Mannheimer an airtight case in the confiscation of two of the four works (the Dosso Dossi and the Degas *Woman Warming Herself*), this was sound strategy.

In January 1967, the German government tribunal recommended that the parties enter into a settlement under which Germany would pay Bernard Goodman and Lili Gutmann DM 61,625 as compensation for their claims to the Dosso Dossi, the Renoir, and the two works by Degas, so that those claims would be *"completely* settled," without any discussion of the evidence or any finding with respect to the individual works.[45] Lili Gutmann and Bernard Goodman each signed a statutory declaration in which each declared:

> For the artistic works which are the subject of the reimbursement proceedings before the Restitution Offices of Berlin—Case No. 22/25/24 WGA 8342/59, I have asserted no other application for compensation, be it on my own behalf or through any institution, organization or authorized agent, nor will I do so in the future.[46]

The DM 61,625 paid by the West German government to Lili and Bernard represented 50 percent of the market value of all four works. Fifty percent was paid on the assumption that there was a fifty-fifty chance that a missing work brought into Germany during the war ended up in West Germany and an equal chance that it ended up in East Germany. In 1991, after the reunification of Germany, Bernard Goodman wrote to the German government asking for the other 50 percent. His request was denied.[47]

POST-1967

Lili Gutmann said that she and her brother Bernard "never stopped looking" for *Landscape with Smokestacks* until it was located in 1995. Lili Gutmann described what she had learned about how to search for missing artwork from the three experts who had appraised the works in the German compensation proceeding:

> And research work is based, of course, first on all the art books about the various artists and also about the catalogues of sales at the important sales houses like Sotheby's or Christie's or whatever they are called.
>
> And, of course, also to follow all the catalogues of exhibitions, exhibitions in museums and all kinds of exhibitions where these paintings might have been published.[48]

By 1967, *Landscape with Smokestacks* had been publicly exhibited in United States museums. In 1968, the landscape was featured in Eugenia Parry Janis's book on Degas monotypes, a book that was available in libraries in London as well as in the United States. The Janis book did not identify Emile Wolf as the owner of the landscape, but stated that it was owned by "a New York collector," as did the book by Adhémar and Cachin published in 1974 in French and in 1975 in English.[49]

If Bernard or Lili had looked at either book before Daniel Searle bought *Landscape with Smokestacks,* they could have required any museum that had had possession of the work to reveal the identity of its then owner. That is what the Goodmans did to learn the identity of the buyer of Gutmann's Renoir when they learned that it had been in the possession of an auction house. When the Goodmans discovered in 1995 that the Renoir had been auctioned at Parke-Bernet in 1969, Sotheby's (who had acquired Parke-Bernet) initially refused to identify the purchaser but was ordered to do so by a New York court. This enabled the Goodmans to locate the buyer of the Renoir and demand its return.[50]

Lili Gutmann acknowledged that if she or the Goodmans had found the Janis book during the period from 1968 to 1987, before Searle bought the landscape, they would have located its then owner, Emile Wolf.[51]

Lili believed that her brother, Bernard, living in London, which was then the "center of the art market," was responsible for checking auction catalogs for the three Impressionist works.[52] Bernard missed the Parke-Bernet catalog of the 1969 auction of Gutmann's Renoir.[53] According to the *Los Angeles Times* interview with his son Nick, Bernard had given up the search after the 1967 settlement in which the German government had compensated Bernard and Lili for the loss of four paintings, including *Landscape with Smokestacks,* and each had agreed not to apply for other compensation in the future. When asked about the *Los Angeles Times* report of his interview, Nick Goodman did not deny that he had told the reporter that his father had given up the search by the mid-1960s, but he testified that he did not recall saying it.[54]

Bernard divorced and lived in London until the early 1970s, when

he moved to Germany to live with his common-law wife, Eva Schultze-Dumbsky.[55] Schultze-Dumbsky said that she and Bernard traveled extensively and that they often visited art museums, looking for missing Gutmann paintings.[56] Bernard visited his sons, Nick, who moved to California in 1968, and Simon, who moved to California in 1980.[57] While in California, Bernard visited museums to see paintings that had once belonged to his father but had been sold by the Gutmann estate after the war.[58] There is no indication that Bernard ever looked for any book on Degas, although the Janis book was in libraries in London and Los Angeles. Bernard had obtained the negatives of his father's three Impressionist works, presumably from his friend Thomas Grange, but he never mentioned the missing paintings to his sons, who received the negatives from Schultze-Dumbsky in 1995, a year after Bernard's death.[59]

Meanwhile, Lili Gutmann was living in Florence, Italy. She had re-married and with her new husband had moved to Greece, but after his death she had returned to Florence.[60] Lili put her search for the paint-ings in context: "Of course we haven't been looking for paintings or artworks for 50 years. We had to live our own lives. We couldn't be running around all the time after the past. We had to do our own pre-sent and building up something and making something of our lives."[61]

Nevertheless, Lili did make attempts to search for the missing paintings after the settlement with the German government in 1967. In 1972, she showed pictures of her father's three Impressionist works to people at Gallery Peter Griebart, a Munich, Germany, firm that maintained a large archive of European paintings and sculptures.[62] The firm found no trace of the missing paintings, but did not claim to have looked for any books on Degas paintings.[63] In 1987, Lili appeared in a German television program on stolen art, displaying the pho-tographs of her father's three missing Impressionist works.[64]

After the Berlin Wall fell in 1989, Lili turned her attention to the possibility that the missing paintings had been taken to Russia. Lili ar-ranged for photographs of the three Impressionist works to be taken to St. Petersburg to be shown to Russians familiar with the Hermitage Museum, as well as with the Pushkin Museum in Moscow, but none of the Russians had ever seen the paintings.[65]

In 1994, Lili Gutmann visited her nephews in Los Angeles. She and

Simon Goodman visited a museum to view a work by Liotard that had been owned by Friedrich Gutmann and sold after the war.[66] But her nephews knew nothing about their grandfather's missing Impressionist works until a 1994 Christmastime telephone conversation during which Lili told Simon Goodman about them.[67] Lili followed that conversation with a January 1995 letter to Nick Goodman identifying the three missing Impressionist works as "Renoir (*Appletree in Bloom*) and two Degas (*Landscape* and Degas woman in front of a fireplace)."[68]

Nick Goodman obtained from his aunt copies of photographs of the three paintings and took them to the Getty Museum in Los Angeles, where a curator identified the Renoir as having been auctioned in 1969 but was unable to help in locating the two pieces by Degas.[69] In May 1995, Nick Goodman visited the Getty Museum to hear a lecture by Lynn Nicholas, the author of *The Rape of Europa*. After the lecture, Nick Goodman introduced himself and asked Nicholas whether she had any ideas about how the Goodman family could locate the two missing works by Degas.[70] Upon her return to Washington, D.C., Nicholas sent Nick Goodman a list of people who might be useful. Included on the list was the attorney Thomas R. Kline of Washington, D.C., "a lawyer specializing in artworks with Willi Korte, a German researcher-expert on the records."[71]

Nick Goodman contacted the people listed by Nicholas and soon was in touch with Willi Korte. In July 1995, Nick Goodman had a telephone conversation with Korte, who gave the same advice that their aunt Lili had received in 1967, when she was advised that in a search for missing art the first thing to do is to look up books about the artist. Korte recommended looking into a catalogue raisonné. Korte also suggested that the missing paintings might have traveled to America.[72]

In September 1995, Simon Goodman took photographs of the missing works by Degas to libraries in southern California in the hope of identifying them in books. Within hours, Simon located three books at the library of the University of California at Los Angeles. He first located Eugenia Parry Janis's 1968 book on Degas monotypes (which would have led the Goodmans to museums at which the landscape had been exhibited and thus to Emile Wolf and then to Searle). Simon

next found the 1974 book by Adhémar and Cachin, which also set forth the exhibitions of the landscape. Simon then found the 1994 exhibition catalog, which illustrated the landscape and identified Daniel C. Searle as the owner.[73]

Having identified Searle, the Goodman family retained Kline as their lawyer to recover *Landscape with Smokestacks*. This led to Kline's December 1995 letter demanding that Searle return the landscape to the Goodmans.

Pretrial Legal Issues

W ITH the conclusion of document production and depositions, the time had come for the parties to file pretrial motions. The case presented two distinct issues. One was whether Friedrich Gutmann owned *Landscape with Smokestacks* when, as alleged, it was stolen by the Nazis or whether he had sold it. The other very different issue was, assuming that the Nazis had indeed stolen the landscape, were Friedrich Gutmann's heirs entitled to recover it from Daniel Searle, who had bought it in good faith after it had been publicly exhibited and published in readily available books for decades? The first issue raised burden-of-proof legal questions. The second raised legal questions relating to the Goodman family's failure to locate the landscape sooner.

BURDEN OF PROOF

Counsel for Searle raised the burden-of-proof issue in a motion for summary judgment. Searle would be entitled to an order dismissing the case without a trial if his counsel could show that there was no genuine issue of material fact with respect to an essential element of the Goodmans' case. Searle's argument was that, as the heirs of Friedrich Gutmann, the Goodmans had the burden of proving that Friedrich Gutmann owned the landscape at the time of his death. Because, Searle argued, the documentary evidence indicated that Gutmann had sent the landscape to Paris to be sold, and because there was no evidence that it had been stolen, the Goodman plaintiffs could not meet their burden of proof. Searle's lawyers relied on decisions of Illinois courts holding that a plaintiff claiming to be the rightful owner of property held by a good-faith purchaser had the burden of establishing title to the property. In other words, the Goodmans had the

burden of proving that the landscape was stolen from Friedrich Gut-mann.[1]

The Goodmans' counsel responded that it would be "preposterous" to conclude that there was no genuine issue about whether *Landscape with Smokestacks* was stolen.[2] The Goodmans stressed that the land-scape was admittedly in Paris at the Wacker-Bondy storage place dur-ing World War II; that the Nazis were stealing Jewish-owned art in massive quantities, including works owned by Friedrich Gutmann from Wacker-Bondy; and that Rose Valland's letter of April 1964 proved that the landscape was seized by a member of the Einsatzstab Rosenberg. The Goodmans stressed that there was no bill of sale or like document proving that the landscape had been sold.[3]

The Goodmans relied on the opinion of Lynn H. Nicholas, who, as the author of *The Rape of Europa*, had conducted extensive research into the Nazi plunder of Jewish art during World War II. In her report prepared for the case, Nicholas described the enormity of Nazi plun-der of Jewish art by the ERR.[4] Nicholas was asked her opinion "as to whether or not the painting *Landscape with Smokestacks* by Edgar De-gas, which was at the time the property of Fritz Gutmann, was stolen in Paris in 1942 or 1943."[5] The dates of the ERR seizure of artwork from Wacker-Bondy were inconsistent because ERR records cited 1942, whereas the information Mrs. Wacker-Bondy gave Frederic Stern indicated 1943.

Nicholas stated that, in her opinion, the landscape "was put into storage in Wacker-Bondy under a non-Jewish name (Muir) by Graupe, who then fled to the United States, and that it was confiscated by the Nazis who were not deceived by this subterfuge."[6] Nicholas re-lied upon the April 1964 letter of "the legendary and incorruptible Rose Valland."[7]

At her deposition, Nicholas backed off any opinion about whether the landscape was stolen in 1942 or 1943. She had no opinion about what year the landscape was taken. It could have been in 1940. It could have been 1944. It was, in her opinion, taken "somewhere between 1940 and 1944."[8] Nicholas also backed off any claim that the ERR had possession of the landscape. Admitting that she knew of no document linking the landscape to the ERR, she argued that some Nazi must have taken it and somehow conveyed it to Hans Wendland sometime during the war.[9]

Neither Nicholas nor the Goodmans' lawyers in their opposition to Searle's motion for summary judgment made any mention of the Goodmans' initial theory that Rose Valland photographed Gutmann's three Impressionist works at the Jeu de Paume. Nor was there any reference to Willi Korte, who had been featured in the media but was not listed as a prospective witness.

Searle replied that nothing the Goodmans relied upon showed that the landscape had been stolen, and contended that the Rose Valland letter not only did not prove that the landscape had been stolen but was inadmissible because it had been prepared for litigation (the German compensation proceeding) and was based on hearsay.[10]

The Goodmans made a backup argument that even if the landscape had been sold, the question of whether the sale was invalid would remain.[11] But there was no showing that the French would have invalidated a sale of the landscape from Paul Graupe to Hans Wendland, who had been found not guilty of complicity in Nazi looting.

Goodmans' lawyers relied on decisions of New York courts holding that Searle had the burden of proving that a landscape was *not* stolen.[12] Searle's lawyers countered, claiming that Illinois, not New York, law applied and that, in any event, the New York decisions relied upon by the Goodmans were inapplicable. Under New York law, Searle conceded, where a plaintiff was the undisputed owner of a work of art when it disappeared, the plaintiff does not have the burden of proving it was stolen. But Searle cited New York cases holding that a plaintiff does have the burden of proving that he or she was the owner at the time the artwork disappeared.[13] In this case, the Goodman plaintiffs claimed ownership of the landscape as heirs of Friedrich Gutmann. But Gutmann sent the landscape to Paris on consignment, raising the question of whether Gutmann owned the work at the time of his death. In other words, according to Searle's argument, the Goodmans had the burden of proving that the landscape had not been sold before it disappeared.

Which party had the burden of proof on a particular issue was a legal question presented to Judge Lindberg in Searle's motion for summary judgment. Whether there was sufficient evidence to sustain whatever burden the Goodman plaintiffs were found to have, and thereby allow the case to go to trial, was another legal question before the court on Searle's motion.

DELAY IN LOCATING THE LANDSCAPE

Searle's motion for summary judgment also argued that, under the Illinois statute of limitations, the Goodmans had to file suit within five years of the time they should have located the landscape. That meant not within five years of 1995, when the Goodmans found that Searle had the work, but much earlier. Searle argued that, by looking at Janis's 1968 book on Degas monotypes or in other ways, the Goodmans should have located the landscape's previous owner, Emile Wolf, long before Searle bought the landscape in 1987.[14]

The law with respect to works of art and other personal property is that the original owner of stolen property is entitled to recover it not only from the thief, but also from a purchaser from the thief, or from a purchaser from a purchaser from the thief. It does not matter how innocent the ultimate purchaser in good faith may be or how much time has elapsed since the theft.[15] In the United States, state statutes of limitations provide a defense to suits for recovery of property, but the time within which to file suit does not begin to run from the date of the theft. In Illinois, a suit to recover stolen property must be filed within five years of the time when the original owner knew, or should have known with due diligence, the identity of the property's current possessor. This so-called discovery rule triggers the time within which suits must be brought under the statutes of limitations of most states.[16]

The application of the discovery rule is illustrated in a New York case whose facts parallel the postwar facts of *Landscape with Smokestacks*. The plaintiff, Gerda DeWeerth of West Germany, had inherited a Monet that, in 1945, was hanging in a castle in which American soldiers were quartered at the end of the war. Following the soldiers' departure, the Monet was missing. DeWeerth made various efforts to locate the painting between 1945 and 1957 but made no further attempts to recover the painting thereafter. In 1957, Edith Baldinger purchased the Monet from a New York art dealer named Wildenstein, who had the painting on consignment from an art dealer in Switzerland. Baldinger purchased the painting in good faith, without knowledge of any adverse claim. On two occasions, Baldinger lent the Monet for display at public exhibitions in New York.

In 1981, twenty-four years after DeWeerth gave up her search, she

told her nephew about the Monet that had disappeared in 1945. The nephew went to a library and identified the missing painting in a book on Monet's works. The book indicated that the art dealer Wildenstein had had possession of the painting. DeWeerth retained New York counsel, who asked Wildenstein to identify the current owner. Wildenstein refused, but a New York state court compelled Wildenstein to identify Baldinger. DeWeerth sued Baldinger in federal court to recover the Monet.[17]

The federal district court awarded the Monet to DeWeerth, finding that she had made a reasonable search so that her demand for the painting had not been unreasonably delayed.[18] The Court of Appeals, in an opinion by Judge Jon O. Newman, reversed the decision of the district court. Judge Newman's opinion first noted that a federal court's role in exercising diversity jurisdiction "is to sit as another court of the state," meaning that in the federal court proceeding the law of the state of New York would govern. In the event of "an absence of controlling state authority," the federal court is obliged to "make an estimate of what the state's highest court would rule to be its law." The federal Court of Appeals believed "that New York courts would impose a duty of reasonable diligence in attempting to locate stolen property."[19] The Court of Appeals also held that application of the legal standard of reasonable diligence to a set of facts in determining whether the statute of limitations barred a claim is a question of law.[20]

The Court of Appeals concluded that DeWeerth had not been reasonably diligent in searching for the Monet, stressing that the painting had been publicly exhibited and included in books about Monet. Judge Newman's opinion concluded:

> DeWeerth's failure to consult the *Catalogue Raisonné* is particularly inexcusable. A *catalogue raisonné* is a definitive listing and accounting of the works of an artist. The Monet *Catalogue Raisonné* depicts each of Monet's works in chronological order and sets forth each work's provenance — a history of its ownership, exhibitions in which it has been shown, and published references to it. The entry for painting number 595, the one here at issue, indicates that Wildenstein sold the painting in the United States in 1957 and that it was exhibited by Wildenstein in 1970. This entry could have eas-

ily directed DeWeerth to Wildenstein. Indeed, when in 1981 De-
Weerth's nephew learned from a cousin of the lost Monet, he was
able to identify it in the *Catalogue Raisonné* within three days,
which led to the identification of Baldinger shortly thereafter. . . .

This case illustrates the problems associated with the prosecu-
tion of stale claims. Gisela von Palm, the only witness who could
verify what happened to the Monet in 1945, is dead. Key docu-
ments, including DeWeerth's father's will and reports to the mili-
tary authorities, are missing. DeWeerth's claim of superior title is
supported largely by hearsay testimony of questionable value.
Memories have faded. To require a good-faith purchaser who had
owned a painting for 30 years to defend under these circumstances
would be unjust. New York law avoids this injustice by requiring a
property owner to use reasonable diligence in locating his property.
In this case, DeWeerth failed to meet that burden.[21]

The facts of DeWeerth's search for the missing Monet are strikingly
similar to the facts of the Goodmans' search for the missing Degas
Landscape with Smokestacks. However, there were problems with
Searle's reliance on this New York federal court case. One was whether
determination of reasonable diligence under Illinois law was a ques-
tion of law for the court or a question of fact for a jury to decide at a
trial.[22] If Illinois courts followed Judge Newman's reasoning, the ques-
tion of reasonable diligence would be decided by the court in deter-
mining when the statute of limitations began to run. But the Good-
mans argued that a question such as reasonable diligence is so
fact-intensive that it must be decided by a jury.[23]

The Goodmans retained expert witnesses who offered opinions on
the subject of reasonable diligence. Lynn Nicholas opined that "the
Goodman family took appropriate steps to recover this property im-
mediately following World War II, a process which they began the
week the war ended in 1945."[24]

Nicholas did not focus on the twenty-year period before Searle
bought the landscape in 1987, a period during which the work was ex-
hibited in museums and published in books available in libraries in
England and the United States. Nicholas testified that in searching for
a work of art, "it would have been normal to consult art libraries,"[25]
but did not address such questions as why Bernard Goodman, living in

London, or his sons, living in Los Angeles, did not look for the catalogues raisonnés on Degas before Searle bought the landscape.

Linda F. Pinkerton, a lawyer and former general counsel of the Getty Museum, was also retained to offer the opinion that the Goodman family had been reasonably diligent in their search for Friedrich Gutmann's Impressionist works. Pinkerton excused the Goodmans' failure until 1995 to look for books about works by Degas because "the publications in which the painting appeared were scholarly and not widely distributed popular books."[26]

Searle's expert, Hermine Chivian-Cobb, opined that "any reasonable research efforts should have located the Landscape long before 1967," when Searle bought it. She based her opinion on the wide availability of the Janis and Adhémar/Cachin catalogues raisonnés in libraries in London and the United States.[27]

Another problem Searle had in relying on Judge Newman's 1987 opinion in the *DeWeerth* case was that his estimate that, under New York law, the statute of limitations was triggered when the original owner should have located the artwork with due diligence turned out to be wrong.

In 1991, New York's highest court dealt with a claim for return of a stolen Chagall painting. The opinion by then Chief Judge Sol Wachtler stated that the New York statute of limitations began to run three years from the date the original owner (the Guggenheim Museum) demanded return of the stolen Chagall painting and the good-faith purchaser refused to return it. The New York court rejected the discovery rule applicable in other states and held that under the New York statute of limitations, the "true owner" has no obligation "to establish that it had undertaken a reasonable search for the missing art," adopting instead a "better rule," which "gives the owner relatively greater protection and places the burden of investigating the provenance of a work of art on the potential purchaser."[28] Thus, the museum's suit was not barred by the New York statute of limitations because suit had been brought within three years of the date the defendant refused to return the painting to the museum.

The New York court acknowledged a "seemingly anomalous" feature of New York law. Where a true owner sues a thief who still has possession of the stolen property, the true owner must bring suit

within three years of the date of the theft "even if the property owner was unaware of the theft at the time that it occurred." The New York court nevertheless held that where a true owner sues a good-faith purchaser, the true owner only has to bring suit within three years of the time the stolen property is located and the good-faith purchaser refuses to return it, no matter how many years after the theft.[29]

The New York court expressly rejected the 1967 estimate of New York law by the federal Court of Appeals in the case of DeWeerth's Monet, stating that the federal court "should not have imposed a duty of reasonable diligence on the owners of art work for the purpose of the Statute of Limitations." This repudiation of the federal Court of Appeals decision did not do the true owner in that case, DeWeerth, any good. She tried to have the federal court judgment that her claim to recover the Monet was barred by the New York statute of limitations vacated because the later decision of the New York state court held explicitly that her case had been decided based on an estimate of New York law that turned out to be wrong. On her second trip to the federal Court of Appeals, that court acknowledged that "it turned out that the DeWeerth panel's prediction [of New York law] was wrong," but held that the prior judgment was final and would not be disturbed.[30] The opinion of the federal Court of Appeals was still relevant in applying the Illinois statute of limitations to the similar facts of the Goodmans' case because, under Illinois law, the discovery rule applies, which is what the federal Court of Appeals estimated New York law to be (erroneously, as it turned out).

Although the Guggenheim Museum escaped the statute of limitations defense to its suit to recover the stolen Chagall painting, it had not won its case. New York's highest court went on to hold that "although the good faith purchaser's Statute of Limitations argument fails, her counterclaim that the museum did not exercise reasonable diligence in locating the painting will be considered by the Trial Judge in the context of her laches defense."[31]

Under both New York and Illinois law, laches is an equitable defense that requires not only a showing of unreasonable delay in bringing suit but also a showing that the delay was prejudicial to the defendant.[32] Thus, if Searle could show that he was prejudiced by unreasonable delay on the part of the Goodmans in locating the land-

scape, he would defeat the Goodmans' suit even if New York law governed. The whole argument about which statute of limitations, Illinois or New York, applied would then become much ado about little of practical significance.

Searle considered it obvious that he was prejudiced by the Goodmans' delay in finding the landscape. If the Goodmans had looked at the Janis book on Degas monotypes at any time after its publication in 1968 and before Searle bought the landscape in 1987, they would have learned that Emile Wolf had the work. If the Goodmans had sued Wolf and won, Searle could not have bought the landscape from Wolf and would not have had the expense of defending this case. And if the Goodmans sued Wolf and lost, the Goodmans would have been foreclosed from suing Searle after he bought the landscape from Wolf. Either way, Searle was prejudiced by the Goodmans' failure to locate the landscape in the decades before he bought it.[33]

The Goodmans, in turn, questioned whether Searle had been reasonably diligent in buying *Landscape with Smokestacks*. Their witness, Linda F. Pinkerton, opined that Searle had not been reasonably diligent because he had not "supervised the purchase [of the landscape] himself," but left the investigation of the work to the curators of the Art Institute.[34] Pinkerton faulted the Art Institute for not asking enough questions about the provenance of the landscape.[35] Pinkerton also faulted Searle and the Art Institute for not contacting the International Foundation for Art Research (IFAR),[36] a registry of missing art that was in its formative stages in 1987. The Goodmans did not register *Landscape with Smokestacks* with IFAR until 1995.[37] Pinkerton concluded: "He [Searle] did not consult either an attorney or an accountant in connection with his purchase of the Painting. He should have done so."[38]

How an accountant would have known more about the landscape than the curators of the Art Institute was not explained. If Searle had consulted an attorney before he bought the landscape in 1987, the attorney, according to Pinkerton, would have told Searle "about the then recent decision of the federal district court in New York in the case of *DeWeerth v. Baldinger*."[39] (That was the federal district court decision that was later reversed on appeal.)

At her deposition, Pinkerton was reminded that she had written an

article entitled "Due Diligence in Fine Art Transactions" in which she took a different view of the diligence required of a buyer of a work of art:

> If the victim of a theft is to be held primarily responsible for finding the object, should the good faith buyer nevertheless be required to check for holders of superior title? In other words, should a good faith purchaser be permitted to purchase an object without bearing the burden of searching title diligently at the time of purchase and searching for possible claimants? Yes, particularly because, as the court stated in *O'Keefe v. Snyder,* there is no available means of performing a title search on works of art and, as the *Kanakaria Mosaics Case* court noted under Swiss law, the court will presume good faith unless the plaintiff can show suspicious circumstances. The good faith of the purchaser should not be so tightly drawn as to require the same level of diligence as that of a victim in satisfying the prerequisite to obtain a tolling of the statute of limitations.[40]

As in the matter of burden of proof, Searle's motion for summary judgment on the issues relating to the Goodmans' delay in locating *Landscape with Smokestacks* presented questions of law for Judge Lindberg to decide.

ILLINOIS LAW OR NEW YORK LAW?

With respect both to the issues of burden of proof and to Searle's statute of limitations defense, the Goodmans' counsel wanted the trial of the case governed by New York law, not Illinois law. This explains why the Goodmans sued Searle in New York. But the case was transferred to Illinois, so, said Searle, Illinois law, including the Illinois statute of limitations, applies. No, said the Goodmans, the New York statute of limitations still applies because, when a case is transferred only for the convenience of the parties, the law of the transferring court still applies.

This generated a convoluted legal argument. The Goodmans' counsel filed a motion for partial summary judgment on statute of limitations defense, which asked Judge Lindberg to decide that New York law governed the case to be tried in his court.[41] Although Judge Sprizzo's transfer order did not specify on what ground the case was

transferred, the Goodmans' counsel argued that the federal court had jurisdiction over Searle in New York (if not, the case would have been dismissed), that the case was not transferred because of improper venue (in which case Illinois law would apply), but that the case was transferred solely for the convenience of the parties (in which case the law of New York applied).[42] Judge Lindberg was asked to decide the issue of jurisdiction and venue although the Goodmans' counsel had agreed to the transfer from New York "in the interest of avoiding litigation of the jurisdiction and venue issue."

Further complicating the matter, Searle argued that even if New York law generally applied, a New York court would apply Illinois law in a case such as this because the subject of the case was Searle's refusal to return the landscape, a refusal by an Illinois resident that did not occur in New York.[43] The Goodmans countered that a New York court would apply its own statute of limitations because it was procedural and, besides, Searle bought the landscape in New York and it was physically in the possession of a New York art dealer when the Goodmans demanded its return.[44]

The question of whether the case was governed by Illinois law or New York law was before Judge Lindberg on the motions for summary judgment filed by both sides.

THE SWISS STATUTE OF LIMITATIONS

As if the timeliness issues in this case were not complicated enough, there was another wrinkle that would have bypassed the question of whether New York law or Illinois law applied—that is, the statute of limitations of Switzerland.

Some European statutes of limitations with respect to suits over stolen property are different from statutes of limitations in the United States in that they begin to run from the date of the theft. Statutes of limitations in the United States do not begin to run until the original owner locates the work of art and its return is refused (New York) or when the original owner should have located the work (Illinois and most other states). Professor von Mehren, the Goodmans' expert on foreign law, testified that in Switzerland the original owner must sue a purchaser in good faith within five years of the theft.[45]

Emile Wolf bought *Landscape with Smokestacks* from Hans Fankhauser of Basel, Switzerland, in 1951, over five years after the end of World War II, during which the landscape was allegedly stolen. According to Professor von Mehren, Wolf would have acquired good title to the landscape in Switzerland if, but only if, there was "evidence establishing that a sale and transfer of the painting was completed" in Switzerland. In other words, said Professor von Mehren, Swiss law would apply only if there were "definitive evidence of a transfer of the painting consummated on Swiss soil."[46]

The late Emile Wolf's passport showed that he had been in Basel, Switzerland, in 1951.[47] Wolf did acquire the landscape from Fankhauser of Basel in 1951. If Wolf consummated the transfer on Swiss soil, then, under the law of Switzerland, Wolf acquired good title to the landscape in 1951 and, as a result, could convey good title to Searle in 1987.[48]

The Goodmans' counsel argued that, just because Wolf was in Switzerland in 1951, it did not necessarily follow that he acquired title to the landscape in Switzerland. Maybe Wolf saw the landscape in Switzerland in 1951 but went home to New York, where he agreed on the price and had the landscape sent to him, in which case the transfer of the work was not consummated on Swiss soil. The inference to be drawn from Wolf's passport may have been for the jury to determine at a trial.[49]

The Goodmans' argument in resisting the application of the Swiss statute of limitations had an incongruous twist. If Wolf did not complete his 1951 acquisition of the landscape in Switzerland, as a result of which the Swiss statute of limitations would not have applied, and if Wolf did complete the transaction upon his return to New York, New York law would have applied. And if that were true, how would it affect Searle's purchase of the landscape in 1987? Searle examined the landscape in New York but did not buy it there. He negotiated the price when he returned to Illinois, and the work was delivered to him in Illinois. Under the Goodmans' theory that Wolf may not have completed the purchase of the landscape in Switzerland in 1951 and thus Swiss law did not apply to Wolf's purchase, Searle's purchase of the landscape was in Illinois and thus Illinois law, not New York law, would govern in this case.[50]

Preparation for Trial

In December 1997, Judge Lindberg ordered a schedule for the filing of briefs and set March 10, 1998, as the date for the parties to appear in court for his ruling on the motions for summary judgment. On March 3, all briefs having been filed, the judge reset the date to appear in court for his ruling on the motions for summary judgment to July 7. On June 22, the ruling on the motions was reset to July 29, 1998, with the ruling to be made by mail. On June 30, the court notified the parties that it would rule on the pending motions for summary judgment by mail, without setting a date for the ruling. Because the pretrial motions were pending, the trial date was extended to May 8, and again to September 9, 1998.

The delay in ruling on the legal issues raised by the motions for summary judgment was understandable. Judge Lindberg, like the other judges in the Northern District of Illinois, carries a heavy load of criminal cases (which have priority under the Speedy Trial Act), civil cases raising federal issues, and other civil cases. The average caseload per judge in this district as of June 30, 1998, was 303 civil cases and 22 criminal cases—up from 228 civil cases and 17 criminal cases only three years earlier.[51] A private dispute over ownership of a work of art is hardly entitled to priority.

By July 1998, counsel for the Goodmans and for Searle faced an unusual situation. The parties were preparing for a September 9 trial without knowing whether Judge Lindberg might grant Searle's motion for summary judgment dismissing the case, which would result in no trial, and without learning, if there were to be a trial, whether Illinois law or New York law would govern. The choice of Illinois or New York law had ramifications beyond the legal issues presented by the motions for summary judgment. In any trial, the jury decides the case only after being instructed by the court on the law. Each side had to draft two sets of proposed jury instructions, one set assuming the jury was to be instructed under Illinois law and the other set assuming New York law.

On July 30, Judge Lindberg's law clerk initiated a conference call with counsel for Searle and Chicago counsel for the Goodmans. The law clerk advised that the judge had decided that the case should go to

trial on September 9. There was no formal order, or opinion, but the news from the judge's law clerk meant that Searle's motion for summary judgment would be denied. The law clerk acknowledged that the judge would have to rule before trial about whether Illinois or New York law governed the case but gave no date for that ruling.

Into August, both parties continued their preparations for trial. The Goodmans' counsel served on Searle's lawyers a proposed pretrial order that included proposed alternative jury instructions under New York and Illinois law. Searle's lawyers were preparing their draft of a pretrial order in response.

On August 7, all preparations came to a sudden halt. The clients had settled.

The Settlement

MOST civil lawsuits are settled, and many settlements are confidential. Not this one. Nick Goodman told the press about the settlement on August 7, 1998. And the Art Institute of Chicago issued a press release setting forth more details of the settlement.

Settlement discussions had been going on sporadically ever since the Goodmans served their demand on Searle. The discussions were conducted not through the lawyers but by Dan Searle dealing directly with either Nick Goodman or Lili Gutmann.

The first round was initiated by Searle shortly after he received the December 1995 letter from lawyer Thomas R. Kline demanding that *Landscape with Smokestacks* be returned to his client, Nick Goodman. Searle looked up Nick Goodman's telephone number in Los Angeles and called him to propose that the dispute over the ownership of the landscape be settled to avoid expensive litigation. Searle assumed that the Goodmans were correct in their statement that the landscape had been sent for safekeeping to Paris, where it was stolen by the Nazis, and Searle knew that he was a purchaser in good faith of a Degas monotype that had been exhibited and published for years before he bought it. On those premises, a fifty-fifty split seemed sensible to Searle, who proposed to Nick Goodman that the landscape be donated to a museum and that each side take a tax deduction for half of its value.

Nick Goodman declined that offer. Searle surmised that the rejection might have been because the Goodmans' income was in a range that would not allow them to benefit fully from such a large tax deduction. So Searle offered to donate the landscape himself, take the tax deduction, and pay the Goodmans half of the tax benefit. This too was declined.

The Goodmans filed suit and document production began. The

premise of Searle's proposed fifty-fifty split, accepting at face value the Goodmans' story about the landscape's having been sent for safekeeping and stolen by the Nazis, was undermined by the documents. Because those documents had been in the possession of the Goodmans' lawyers, Searle believed the Goodmans should have known better than to assert the story about safekeeping and theft. Searle felt so strongly that he characterized the Goodmans' claim as "extortion,"[1] a term that angered Nick Goodman.[2]

As the case progressed, Judge Lindberg encouraged settlement. At periodic status conferences, the judge would ask counsel about the prospects of settlement. In June 1997, Judge Lindberg took the initiative. Counsel for each side had drafted an agreed order amending the pretrial schedule, a typewritten document presented to the court for approval. Before signing, Judge Lindberg inserted the following handwritten paragraph:

> ordered, party plaintiffs and defendant to confer face to face for settlement discussions, November 5, 1997 or earlier. Report attendance and progress 12/2/97 @ 9:30 a.m.[3]

In September 1997, before her deposition in Chicago, Lili Gutmann called Dan Searle's home in the hopes of setting up a one-on-one meeting, but Searle was in England.[4] During her deposition, with Nick and Simon Goodman present, an attempt was made to set up the face-to-face meeting of the parties ordered by Judge Lindberg.[5] Conflicting schedules led the parties to have a telephone conference call (Nick and Simon Goodman in Los Angeles, Lili Gutmann in Florence, and Dan Searle in Chicago). Nothing came of the conference call.

Lili Gutmann still wanted to meet Dan Searle face-to-face. A meeting was arranged in November 1997 at a conference room at London's Heathrow Airport. The meeting was cordial. Searle believed that Lili Gutmann had presented to him two alternative suggestions for settling the case. When he returned to Chicago, Searle wrote to her, setting forth his understanding of her two proposals and advising that either one would be satisfactory to him.[6] A week later Lili Gutmann responded that what she called Searle's suggestions were completely unacceptable.[7] There had been either a total failure of communication in London or a change of position.

Lili Gutmann proposed another alternative: share the landscape fifty-fifty, with Searle donating his half and the Goodmans selling their half.[8] Searle rejected that idea, repeating that the documents produced by the Goodmans' lawyers did not show that the landscape had been sent to Paris for safekeeping and then stolen.[9] In reply, Lili Gutmann stressed her continuing belief that the landscape had been stolen.[10]

In January 1998, Goodman lawyer Kline wrote to counsel for Searle spelling out in greater detail Lili Gutmann's settlement proposal, namely a fifty-fifty split of the landscape, with Searle donating his half to the Art Institute of Chicago and the Goodmans selling their half to the same institution.[11] Searle was not interested at that time. By then, discovery was complete and Searle's motion for summary judgment had been drafted. Relatively little further expense would be incurred by awaiting Judge Lindberg's ruling on the motion. If the judge granted the motion, the case against Searle would be dismissed. If the motion was denied, the judge would presumably issue an opinion clarifying the issues, and there would be time before a trial began to consider a settlement.

As it turned out, there was no opinion from the court on Searle's motion for summary judgment, only the July 30 telephone call from Judge Lindberg's law clerk telling counsel that the case would go to trial on September 9.

On August 7, Nick Goodman telephoned Searle and proposed that the case be settled on the terms proposed in January. After consulting with his lawyers, Searle called Nick Goodman back the same day and agreed. The lawyers for both sides ceased preparations for trial. Judge Lindberg's clerk was notified.

What motivated the Goodmans and Searle finally to settle the case at this stage? The prospect that there will actually be a trial often focuses litigants' minds on settlement. Many cases are settled just before trial — settled on the courthouse steps, as it were.

One important factor in this case was incurring the expense of a trial that could go on for weeks. Lawyers' fees would mount up, witnesses would have to be brought to Chicago from across the United States and Europe, and court reporters would have to be paid, among other expenses. In addition to the expense of the trial itself, whatever

the outcome, there would be the prospect of the further expenses of posttrial motions and appeals.

Indeed, lawyers' fees had already mounted. But Searle had resisted a cash settlement to the Goodmans while there was still the possibility that Judge Lindberg would grant pretrial motions that would avoid a trial. Searle resented the continuing media campaign that he believed was orchestrated by the Goodmans and their lawyers. Searle also resented the idea that most of the money would go to the Goodmans' lawyers, who, in Searle's opinion, had the documents and thus "should have known better than to assert the story about safekeeping and theft."[12] Imminence of trial, however, significantly increased the stakes.

The Goodmans were also concerned about the costs of the case. Although their lawyers were working on a contingent fee basis, the Goodmans placed an advertisement in the Jewish publication *Forward* in February 1998, appealing for contributions to help defray the costs of the trial. The introduction to that advertisement is shown in illustration 7. The text of the advertisement was as follows:

> Fritz Gutmann and his wife Louise were two of the six million Jews whose lives were extinguished during the Holocaust. The Nazis took Fritz and Louise and they also took the art they collected and loved—including their prized Degas *Landscape with Smokestacks.*
>
> For the past 50 years, two generations of Gutmanns (now Goodman) have searched the globe for fragments of their forefathers' collection. When they discovered their Degas, it was hanging in the United States, in someone else's collection.
>
> The hope for moral restitution and a return of the Degas is a landmark legal case that is going to trial in May 1998 in Chicago.
>
> The outcome of this case will set a precedent that could help thousands of Holocaust victims in the United States whose art was stolen by the Nazis. The Goodman family has limited financial resources. The case began more than two years ago and has cost the family many thousands of dollars. It is critical that the family have the resources available to make their case fully in court. They need your help![13]

Apart from the costs, the imminence of trial forces each party to take a realistic, cold-blooded view of the chances of success. Neither

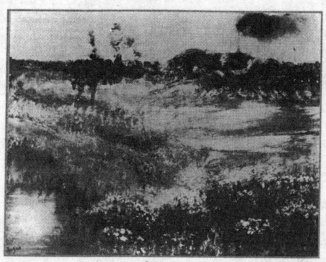

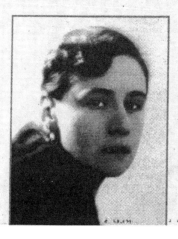
7. The Goodman family's ad in the February 1998 Forward *featured
Friedrich and Louise Gutmann.*

the Goodmans' lawyers nor Searle's could candidly advise their clients that their side was a sure winner.

The Goodmans had a powerfully emotional case to present to a jury. Their parents/grandparents had been murdered by the Nazis, and the Nazis were guilty of stealing massive quantities of artwork from Jews in occupied countries, including works owned by the Gutmann family. The flaw in the Goodmans' case was the lack of evidence tying this tragic story to *Landscape with Smokestacks*.

Searle's lawyers believed they had a strong defense on two fronts. One was based on the documents indicating that the landscape had been sent before the war to Paris to be sold and the absence of any documents showing that the landscape had been stolen. Because there was no witness with any personal knowledge of what happened to the landscape during World War II, the issue of what happened to the artwork turned on the documents (a circumstance that would be particularly important in any appeal from an adverse jury verdict, because there would be no issue of the credibility of fact witnesses for a jury to resolve). Searle's second and separate defense was his status as a good-faith buyer who relied on the curators of the Art Institute. To Searle, it seemed only fair that one should be safe in buying a work of art decades after it had been publicly exhibited and published in widely available books. But a jury might well have great sympathy with Lili Gutmann and her tale of decades of search. With the landscape finally found in the hands of a wealthy suburbanite, might not a juror conclude that the Goodmans should be given the property that had once belonged to their murdered parents/grandparents?

Logically, the 1943 murders of Freidrich and Louise Gutmann by the Nazis are irrelevant to *Landscape with Smokestacks*. By 1943, whatever happened to the landscape had already happened. It would have made no difference to the story of the landscape if the Gutmanns had died of natural causes in their Holland home instead of being murdered in 1943. The landscape had been sent to Paris four years earlier, the ERR had seized one of Gutmann's works by Degas a year earlier, and the Degas landscape, if not seized then, had been sold even earlier. Despite its lack of logical connection to the Goodmans' claim to the landscape, the tragic murder of their parents/grandparents was the most powerful emotional factor favoring the Goodmans' claim.

Counsel for Searle could have filed a pretrial motion for an order barring plaintiffs from telling the jury about the murders on the ground of irrelevance. But it was problematic whether such a motion would be granted and, even if granted, whether the jury might learn of the murders anyway.

Another incentive for settlement was that the parties could compromise, whereas a jury could not. In court, this was a winner-take-all case. Unlike a suit for damages, in which a jury could compromise, this case was about who was entitled to possess the landscape. If the case went to trial and the Goodmans won, they would get the landscape. If Searle won, he would keep it.

Upon consideration of the expenses and risks of litigation, the Goodmans and Searle each decided that the case should be settled on the eve of trial.

There remained the task of drafting a formal settlement agreement, one that required participation of the Art Institute, obligating it to pay the Goodmans for their half of *Landscape with Smokestacks*. Agreement on the process for determining its value was also required. And the Goodmans wanted an acknowledgment when the landscape was exhibited.

The formal settlement agreement was signed as of August 13, 1998. It incorporated the terms of the agreement to split the ownership of the landscape fifty-fifty, spelled out the mechanics for determining its value, bound the Art Institute to pay half the work's value to the Goodmans, and required that Searle donate his half to the Art Institute. The Art Institute issued a press release:

GOODMAN FAMILY AND DANIEL SEARLE ANNOUNCE
SETTLEMENT OF WORLD WAR II ART RESTITUTION CASE

Heirs of two Holocaust victims killed during World War II, and Daniel C. Searle, Life Trustee of The Art Institute of Chicago, reached a settlement today over ownership of *Landscape with Smokestacks*, a pastel monotype by Edgar Degas. Under the settlement, 79-year-old Lili Vera Collas Gutmann and her nephews Nick and Simon Goodman, daughter and grandsons, respectively, of Holocaust victims Friedrich and Louise Gutmann, and Mr. Searle will share equally in the work of art.

As part of the settlement, the Goodmans and Mr. Searle asked

The Art Institute of Chicago to acquire the pastel to share with the public. According to the agreement, two independent third parties will appraise the pastel. Based on the average appraisal value, the Art Institute will purchase the Goodmans' half-interest in the work, and Mr. Searle will donate his half-interest to the Art Institute. The agreement also stipulates that the Art Institute will bring the pastel into its collection as a purchase from the collection of Friedrich and Louise Gutmann and a gift of Daniel C. Searle. . . .

Nick Goodman, speaking on behalf of his family, said: "This settlement, which allows us to preserve the pastel's history in one of the country's finest art museums, represents a fair resolution to this complex case."

Speaking for the museum, Art Institute Director and President James N. Wood said: "The Art Institute has become a historically and artistically richer museum today, thanks to the Goodman and Searle families. The acquisition of Degas's *Landscape with Smokestacks* allows the Art Institute to bring an important work of art to the public while taking into account the history of World War II and the Holocaust."[14]

Upon the signing of the final settlement agreement, counsel for the parties filed a stipulation of dismissal with Judge Lindberg, who thereupon entered the following order:

Minute Order of 8/19/98 by Hon. George W. Lindberg

Pursuant to Rule 41(a)(1) of the FRCP this action is dismissed in its entirety with prejudice, with each party to bear his or her own costs. Terminating case mailed notice.

Thus ended the court case.

The settlement agreement provided that the fair market value of *Landscape with Smokestacks* would be the average of two independent appraisals, one appraiser to be either Christie's or Sotheby's auction house, at the election of the Goodmans, and the other to be an individual appraiser selected by the Goodmans from a list of appraisers provided by the Art Institute. The costs of the appraisals would be split three ways, among Searle, the Goodmans, and the Art Institute.[15] The Goodmans promptly selected Christie's and Richard Feigen as the two appraisers.

In November 1998, the Art Institute advised the parties of the re-

sults of the appraisals.[16] Richard Feigen reported the fair market value of the landscape as $575,000. Christie's reported the fair market value as $300,000. The average of the two appraisals was $437,500. This provided the basis for Searle to obtain an income tax deduction of $218,750 for the donation of his half of the landscape to the Art Institute. The Art Institute tendered to the Goodmans $218,750 in payment for their half of the landscape, but that payment was not accepted.

The Goodmans and their lawyer, Kline, were bitterly disappointed with the appraisals. In November 1998, Kline wrote a long letter to counsel for the Art Institute decrying what he characterized as "terribly deficient appraisals." Based upon a lengthy review of sales of other Degas landscapes, Kline concluded that "the true value of *Landscape with Smokestacks* would surely be found in the $800,000 to $1.2 million range. . . . To the Goodmans, it is inescapable that a fair value for this work can only be found in this range."[17] Counsel for the Art Institute told Kline that his complaint should be directed to the two appraisers, not the Art Institute.[18]

A January 1999 article in the *Wall Street Journal* quoted Nick Goodman as saying that he was "looking for a value of about $1 million" and that "we are hoping to talk to Christie's to see if they will reconsider. [If the appraisals stand], we will be out-of-pocket [for expenses in pursuing the landscape] by about $100,000."[19]

Kline did ask Christie's to reconsider. In April 1999, Christie's sent to the Art Institute its revised fair market appraisal of Degas's *Landscape with Smokestacks*. Christie's said: "[W]e have increased our appraisal to $400,000, based largely upon our sale on November 19, 1998 of another pastel. This was, of course, subsequent to the completion of our previously submitted appraisal."

The November 19, 1998, sale of the other Degas pastel (*Plage à marée basse*, 1869) was for $321,500. Although "this work may have broader appeal to collectors than the Searle work," Christie's opined that "the Searle pastel should be valued higher" because "it is indisputably the more important one in terms of its later date, fully mature technique and visionary approach to the landscape."[20]

Feigen's appraisal of $575,000 remained unchanged. Thus, the average of the two appraisals became $487,500, Searle's deduction for

donation of his half of the landscape became $243,750, and the Good-
mans' share became $243,750 (less one third of the appraisal costs),
which the Goodmans agreed to accept in mid-May 1999.[21] The net ef-
fect of the delay was to increase Searle's tax deduction and the Good-
mans' payment each by $25,000.

The appraised value of *Landscape with Smokestacks* was not the
Goodmans' only disappointment. The litigation in London over own-
ership of Friedrich Gutmann's Renoir was also settled on the basis of
a fifty-fifty split of the ownership, with the work to be sold and the
proceeds equally divided. The Renoir was placed at auction at
Sotheby's in London, where it was estimated to bring $252,000 to
$336,000. A *Wall Street Journal* article reported that the Renoir failed
to find a buyer at a December 1998 auction.[22]

The Goodmans and their lawyer had greatly overestimated the val-
ues of both works they were seeking to recover. The situation was
ironically reminiscent of Bernard Goodman's reaction to the Dutch
litigation over his father's estate in the 1950s: "The entire affair lasted
years and very little came of it—only the attorneys made money on
it."[23]

The net result of the Goodmans' suit to recover *Landscape with
Smokestacks* is that the Goodmans were paid $243,750 by the Art In-
stitute, whose curators wanted the landscape for their collection in
1987 but could not then afford it, and Dan Searle, who paid $850,000
for the landscape in 1987, obtained an income tax deduction of
$243,750.

The primary beneficiary of this settlement is the public, who
can now view Edgar Degas's unique work of art. *Landscape with
Smokestacks,* which had been held in storage during the litigation, was
placed on public display at the Art Institute in June 1999.[24]

Postmortem

WHAT, if anything, is to be learned from the litigation over *Landscape with Smokestacks?* After the settlement, Thomas Kline, counsel for the Goodmans, told a reporter what he had learned: "I am almost at the point of saying that if the art isn't worth $3 million, don't go after it."[1] This seems an overgeneralization. The Goodmans' case was uniquely difficult because of documents indicating that the landscape had been sent to Paris before the war to be sold, the absence of any proof that it was stolen, and the failure of the Goodmans to locate it in the decades during which it had been publicly exhibited and published. It would be a far easier case if the Goodman family were someday to locate Friedrich Gutmann's other Degas, *Woman Warming Herself,* which has not been seen since it was seized by the ERR in 1942.

What second thoughts might occur to Daniel Searle? Should he have protected himself against losing the landscape to the Goodmans by suing art dealer Margo Schab and prior owner Emile Wolf? If Wolf did not have good title to the landscape, Searle might have been able to recover the money he paid for the work.[2] But defending the Goodmans' case in Illinois was expensive enough without incurring the additional cost of suing Schab (who was only the broker) and the Wolf estate in New York, particularly when Searle's counsel believed that Wolf had a valid defense, namely that Wolf had acquired good title in Switzerland. The Goodmans' counsel argued that Searle should have protected himself by purchasing title insurance,[3] but title insurance for works of art, even if it had been available in 1987, is irrelevant to the question of who was entitled to the landscape itself, the Goodmans or Searle.

What can other parties learn about contesting claims to other works of art? Increasing interest in the massive thefts of art by the Nazis

during World War II led the Association of Art Museum Directors in June 1998 to issue guidelines for dealing with claims for recovery of Nazi-looted art.[4] The Washington Conference on Holocaust-Era Assets was convened by the U.S. Department of State in December 1998, at which Stuart Eizenstat, the Undersecretary of State for Economic and Business Affairs, "lauded as a model" the settlement agreement between the Goodmans and Searle.[5] At the conference, Ralph Lerner proposed that future controversies over ownership of art allegedly stolen by the Nazis be submitted to mediation or arbitration rather than to the courts. Nick Goodman agreed, stating that "winner-take-all litigation, is only cost effective for the most expensive art" and is "a terrible waste of money, no matter how it comes out."[6] Submitting a dispute over ownership of a work of art to arbitration would not be "winner-take-all litigation" only if the parties' agreement to arbitrate authorized the arbitrator to compromise.

The Washington Conference on Holocaust-Era Assets developed a set of nonbinding "Principles with Respect to Nazi-Confiscated Art." One of the principles (no. IV) is: "In establishing that a work of art had been confiscated by the Nazis and not subsequently restituted, consideration should be made for unavoidable gaps or ambiguities in the provenance in light of the passage of time and the circumstances of the Holocaust era." This is a reasonable approach. But it is doubtful that such a principle, if adopted, would have had significant effect in the case of *Landscape with Smokestacks*, given the unusual fact that the Nazi theft of Friedrich Gutmann's other Degas (*Woman Warming Herself*) from Wacker-Bondy was documented, whereas many of Gutmann's works of art that had also been sent to Wacker-Bondy had been sold before the Nazis arrived.

What can be learned about the media? The media coverage of the filing of the complaint in 1996 accepted the Goodmans' story, as indeed did Searle until the contradicting documents were produced. But authors of newspaper and magazine articles, although informed about the contradicting documents, told and retold the Goodmans' story about safekeeping and seizure by the Nazis.

An example is the one-hour, British-produced documentary broadcast nationally on public television in 1998. The show was produced after discovery had been completed and the producers had been told

about the documents. Almost the entire hour of the television show is devoted to Lili Gutmann's tragic story and the evils of the massive thefts of art from Jews in Nazi-occupied countries. Toward the end of the hour, Searle and his counsel are shown in clips. The overall impression that the documentary conveys is summarized in this review in a London newspaper television schedule: "The Gutmann family is going to court to try to retrieve a painting by Degas which they say is theirs. The art world is holding its breath. The painting is in the possession of Daniel Searle, an American pharmaceuticals billionaire, who paid $850,000 for it and won't give it up. Why should he? Because, say the Gutmanns, it is one of several works of art stolen from them during the Second World War by the Nazis, and it is only the unscrupulousness of dealers and collectors that has prevented this truth from emerging before now."[7] Karl Haberstock was vilified in the television broadcast as an unscrupulous dealer, although it has never been suggested that he had any connection whatever with *Landscape with Smokestacks*. Hans Wendland was vilified by Willi Korte in the television broadcast with no mention of Wendland's acquittal of complicity in Nazi looting by the French military tribunal.

The coverage of this story by the press and television is understandable. Authors of articles and producers of television shows are driven to produce interesting features that will sell newspapers and magazines and attract television viewers.

Landscape with Smokestacks seems to be newsworthy only if it can be described as looted by the Nazis. When the landscape was first placed on public display at the Art Institute in mid-June 1999, the *Chicago Tribune* featured an article reporting that "the monotype once belonged to a wealthy Dutch couple who perished in the Holocaust and whose extensive art collection was looted by the Nazis." The article itself was entirely factual; it does not say that the landscape was looted by the Nazis. But the headline was "War-Loot Degas Goes on Museum Display."[8]

What can be learned by the art world, said to have been holding its breath awaiting the outcome of the Goodmans' court case against Searle? The settlement left many questions unanswered. But the art world was presumably not holding its breath to find out whether Illinois law or New York law governed the trial, or whether Rose

Valland's April 1964 letter was admissible in evidence and, if so, what it proved. Perhaps the art world was holding its breath to see whether the Goodmans or Searle won. But how would resolution of the dispute over the ownership of one work of art affect the art world? Hermine Chivian-Cobb, who has spent her adult life in the art world, expressed her hope for an end to uncertainty: "Based on my experience with art dealers, museums and collectors, it is my belief that it would cause marked uncertainty in the art market if, after fifty years had passed since the events in issue, and everyone with personal knowledge had passed away and relevant documents were no longer available, the ownership of a buyer who relied on a provenance showing decades of public exhibition in purchasing an art work through a reputable dealer could be set aside."[9] But any hope that the *Goodman v. Searle* case, whatever its outcome, would produce certainty for the art world was an illusion.

The most certainty that Chivian-Cobb could have hoped for in this case would be a decision by the United States Court of Appeals for the Seventh Circuit that adopted the approach of Judge Newman in the *DeWeerth* case in the Second Circuit, holding as a matter of law that the buyer of a work of art that had been widely exhibited and published for many years was protected by the statute of limitations from a suit by the original owner. Even if there had been such a decision in this case, however, it would be only an estimate of Illinois law by one federal Court of Appeals and, if correct, would be the law of one state whose statute of limitations was applied in a manner different from that of New York. If, as Judge Lindberg implicitly decided in allowing the case to go to trial, the question of reasonableness of search was to be left to a jury, there would be no protection from the uncertainty of litigation no matter what the jury in this case might have decided.

Regarding the other issue in this case, whether the landscape was stolen or sold, the outcome would not have much significance, if any, to the art world because it would have had no relevance to any of the massive volume of art known to have been stolen by the Nazis.

If this case had not been settled and if the timeliness issues did not dispose of the case, the jury and ultimately the Court of Appeals would have had to resolve the stolen-versus-sold issue on the basis of the documentary evidence. There were no witnesses with personal

knowledge of what happened to *Landscape with Smokestacks* during World War II. The expert witnesses — for the Goodmans, Lynn Nicholas, whose experience was as a researcher, and for Searle, Hermine Chivian-Cobb, whose experience was in the art world — knew only what they concluded from their respective reviews of documents that are more than fifty years old. The jury, Judge Lindberg on posttrial motions, and the Court of Appeals could have reached their own conclusions after analyzing the same documents.

So could you, the reader. That is why this book quotes at length from the significant documents. Was *Landscape with Smokestacks* sent to Paris for safekeeping and stolen by the Nazis? Or was it sent to Paris on consignment and sold? Draw your own conclusion.

Acknowledgments

Because most of this book is based on the research undertaken in the case of *Goodman v. Searle,* I am indebted to my colleagues in the litigation, Henry Mason, Tom Cauley, Steve Bierman, and Susan Davies, for their dedication to the case. Special thanks go to Henry Mason and Hermine Chivian-Cobb for their relentless translation and analysis of the thousands and thousands of documents, most of which were in the French, German, or Dutch languages.

After the settlement, when I decided to put together a book to set forth the details underlying the surface of the media reports of the case, I was fortunate to gain the help of Scott Stone. Scott had graduated from Northwestern University's Medill School of Journalism and was considering applying for admission to law school. He mastered the complex record in the case, provided valuable research, and prepared initial drafts of the first several chapters. Gail Copley contributed greatly by word processing draft after draft of the manuscript.

Constructive suggestions were made by Henry Mason and Tom Cauley in their reviews of earlier drafts and by internal and external reviewers for the Northwestern University Press. I am grateful to Newton Minow, my partner of fifty years, for not only reviewing the manuscript but also writing the thoughtful foreword.

I am also grateful to the Northwestern University Press, particularly to Susan Harris and Sue Betz, for transforming this story from a manuscript into this book.

Notwithstanding all this help, the responsibility for the book is mine alone.

Notes

Unless otherwise specifically indicated, the documents cited were produced by the parties during discovery in *Goodman, et al. v. Searle*. Each page of each document is identified by the party that produced the document and a page marker. The number following the abbreviation "NSLG" (Nick, Simon, and Lili Goodman/Gutmann) refers to the page of a document produced by the plaintiffs, and the number after "DCS" (Daniel C. Searle) refers to the page of a document produced by the defendant.

The Chivian-Cobb affidavit is frequently cited. Hermine Chivian-Cobb is the expert witness retained by Daniel Searle to review the documentary history of *Landscape with Smokestacks* and to render opinions about whether the landscape had been stolen or sold during World War II and whether the landscape could have been located with reasonable diligence in the decades before Searle bought it. Chivian-Cobb's qualifications, as set forth in her affidavit, include fluency in foreign languages and extensive experience in the art world, at the Metropolitan Museum of Art and Sotheby's in New York, and as an appraiser of artworks and a private dealer in art.

When the Chivian-Cobb affidavit is cited following the citation to an NSLG document that is in a foreign language, the affidavit provides a translation of the relevant portion of the NSLG document. When the affidavit is cited alone, it contains opinions by Chivian-Cobb as an expert witness.

Preface

1. Lynn H. Nicholas, *The Rape of Europa: The Fate of Europe's Treasures in the Third Reich and the Second World War* (New York: Random House, 1994).

Chapter One

1. Eugenia Parry Janis, *Degas Monotypes: Essay, Catalogue and Checklist* (Cambridge: Fogg Art Museum, Harvard University, 1968). *Landscape with Smokestacks* is number 68 in this catalog.
2. Janis, *Degas Monotypes,* "[D]essins faits avec l'encre grasse et imprimés," p. xvii.
3. Ibid.
4. Janis identified over three hundred in existence in 1968, and recognized that Degas had done many more. Janis, Preface to Checklist.
5. Janis, *Degas Monotypes,* number 68.
6. Ibid.
7. Richard Kendall, *Degas: Beyond Impressionism* (London: National Gallery Publications, 1996), p. 10.
8. Galerie Georges Petit, *Catalogue des tableaux, pastels et dessins par Edgar Degas, Paris, July 2–4, 1919. Landscape with Smokestacks* is number 45 in this catalog.

Chapter Two

1. Schab deposition, p. 150.
2. Ibid., p. 145; Druick deposition, pp. 73–74.
3. McCullagh deposition, p. 135.
4. Searle deposition, p. 14.
5. McCullagh deposition, p. 86.
6. Searle deposition, pp. 23, 28.
7. Druick deposition, p. 21.
8. Searle deposition, p. 26.
9. Ibid., pp. 26–27.
10. Ibid., pp. 27–28.
11. Druick deposition, pp. 18–21.
12. McCullagh deposition, p. 89.
13. Ibid., pp. 106–7.
14. NSLG 00331–32. Provenance, exhibitions, and literature of *Landscape with Smokestacks* supplied by Margo Pollins Schab, Inc., in 1987.
15. Schab deposition, pp. 160–61.
16. Janis affidavit, p. 2.
17. NSLG 03933. Letter from Emile Wolf to Eugenia Parry Janis dated October 21, 1967, in response to a letter he received from her dated October 12, 1967, providing provenance information for the landscape.
18. Searle deposition, pp. 29–30.

19. Ibid., p. 11.
20. Ibid., p. 106.
21. Exhibit 23 to Searle deposition.
22. Searle deposition, p. 253.
23. Exhibit 22 to Searle deposition.
24. Searle deposition, p. 33.

Chapter Three

1. Letter from Kline to Searle dated December 5, 1995.
2. *Autocephalous Greek Orthodox Church of Cyprus v. Goldberg & Feldman Fine Arts, Inc.,* 717 F.Supp 1374 (S.D. Ind. 1989), affirmed 917 F.2d 278 (7th Cir. 1990).
3. Thomas R. Kline, "Legal Issues Relating to the Recovery of the Quedlinburg Treasures," in *The Spoils of War: World War II and Its Aftermath: The Loss, Reappearance, and Recovery of Cultural Property,* ed. Elizabeth Simpson (New York: Harry N. Abrams, 1997), p. 157.
4. Television documentary, "Making a Killing: A Legacy Stolen by the Nazis," produced by London-based Legend/Diverse, broadcast in England and in the United States over public television in 1998.
5. Ibid.
6. SHOAH interview, p. 1.
7. *Los Angeles Times,* July 19, 1996, p. B6.
8. NSLG 03981–82. An entry in a directory of Dutch businessmen for "Gutmann, Fritz Bernard Eugen."
9. NSLG 00059–64. Claim and settlement agreement between Lili Gutmann and Bernard Goodman and the trust to which Friedrich Gutmann was indebted. Filed with the Council of Recuperation, Judicial Division, at The Hague. Undated. NSLG 03087–88. Letter from Dr. Ginlio T. Mattioli to the German art dealer Julius Boehler dated July 7, 1942.
10. NSLG 03685–86. Photograph of *Adoration of the Magi* by the Master of St. Bartholomew's Altar, with Lili Gutmann's handwriting on the back stating the work belonged to her father, Friedrich Gutmann, and was sold before the war. NSLG 03697–98. Photograph of a portrait of Duke Sigismund by Ercole di Roberti, with Lili Gutmann's handwriting on the back stating the work belonged to her father, Friedrich Gutmann, and was sold before the war.
11. NSLG 04047–50. German-language document, undated, describing Friedrich Gutmann's property and what happened to it. NSLG

01416–17. German-language document, dated 1949, describing Friedrich Gutmann's business dealings with the German art dealers Karl Haberstock and Julius Boehler.

12. NSLG 00132. Letter from Arthur Goldschmidt on "Paul Graupe & Co." letterhead to "Fa. de Gruyter & Co." Shipping form dated April 22, 1939.

13. SHOAH interview, p. 13.

14. Ibid., p. 17.

15. Lili Gutmann deposition, p. 18.

16. Ibid.

17. NSLG 00012. Letter from Heinrich Himmler to the Italian ambassador to Germany dated June 11, 1942. In June 1942, Friedrich Gutmann received a copy of the following response to an inquiry from the Italian ambassador to Germany:

> Following your letter of 31.3.42, I notify you that no measures have been carried out against the Jew and Dutch citizen Gutmann, who resides in Heemstede near The Hague. . . . According to your wishes, I have ordered my office at The Hague to leave Gutmann in his house and to except him and his wife from any kind of security police measures.
>
> H. Himmler

18. Lili Gutmann deposition, p. 27.

19. Quote from the Legend/Diverse television documentary.

20. SHOAH interview, pp. 23–25.

21. Lili Gutmann deposition, pp. 32–33.

22. Ibid., p. 33.

23. Ibid., pp. 34–35.

24. Ibid., p. 36.

25. SHOAH interview, pp. 29–30.

26. Ibid., p. 43. Lili Gutmann deposition, p. 100.

27. Jonathan Petropoulos, *Art as Politics in the Third Reich* (Chapel Hill: University of North Carolina Press, 1996), p. 181.

28. Ibid., pp. 187–88.

29. Nicholas, *Rape of Europa*, pp. 135–36.

Chapter Four

1. Letter from Kline to Lerner dated February 7, 1996, p. 2.

2. Ibid.

3. Ibid., pp. 2–3.

4. Letter from Kline to Lerner dated February 20, 1996, p. 1.

5. Ibid., p. 3.

6. Nicholas, *Rape of Europa*, pp. 165–69.

7. Letter from Kline to Lerner dated February 20, 1996, p. 4.

8. Letter from Kline to Lerner dated April 26, 1996, p. 3.

9. Ibid.

10. Letter from Lerner to Kline dated May 9, 1996.

11. Letter from Kline to Lerner dated June 14, 1996.

12. Complaint in *Goodman, et al. v. Searle*, no. 96 CIV. 5310 (S.D.N.Y. filed July 17, 1996).

13. Ibid., paragraphs 12, 15, 18, 19, 25.

14. *Los Angeles Times*, July 19, 1996, pp. B1, B6.

15. *Washington Post*, July 19, 1996, pp. B1–B2.

16. *Wall Street Journal*, July 19, 1996, p. B11.

17. Quotes from Legend/Diverse television documentary.

18. Hector Feliciano, *The Lost Museum: The Nazi Conspiracy to Steal the World's Greatest Works of Art* (New York: Basic Books, 1997), pp. 114–15, 184, 188.

19. Exhibit 5, p. 2, to Kline affidavit in support of plaintiffs' motion for partial summary judgment on statute of limitations defense, October 22, 1997.

20. Ibid.

21. Ibid.

22. Order of Judge Sprizzo dated September 24, 1996, in *Goodman, et al. v. Searle*, no. 96 Civ. 5310 (S.D.N.Y.).

23. Order of Judge Lindberg dated November 26, 1996 in *Goodman, et al. v. Searle*, no. 96 C 6459 (N.D. Ill.).

Chapter Five

1. NSLG 00132. Letter from Arthur Goldschmidt on "Paul Graupe & Co." letterhead to "Fa. de Gruyter & Co." Shipping form dated April 22, 1939.

2. Legend/Diverse television documentary.

3. Chivian-Cobb affidavit, paragraph 13.

4. Quote from Legend/Diverse television documentary.

5. NSLG 00755. Friedrich Gutmann's handwritten note, undated, Lili Gutmann's translation. Attachment A to a letter from Kline to Lerner dated February 7, 1996.

6. Lili Gutmann deposition, p. 309.

7. NSLG 00036. Letter from F. Stern to Bernard Goodman dated September 26, 1945.

8. NSLG 00882. Certification of Paul Graupe dated March 3, 1947.

9. NSLG 01848–50. Letter from Arthur Goldschmidt to Paul Simon dated November 20, 1945.

10. Chivian-Cobb affidavit, paragraph 9n2

11. NSLG 01345–46. Exhibition catalog of Galerie Andre Weil, Paris, June 9–30, 1939.

12. NSLG 00823. Letter from K. G. Boon of the Stichting Nederlandsch Kunstbezit (SNK, the Dutch government's art recovery and restitution agency) to A. S. Henraux, president of the Commission de Récupération Artistique (the French government's equivalent of the SNK), dated January 23, 1947. The letter's fourth paragraph described Arthur Goldschmidt's removal of several Gutmann works of art (including the three Impressionist pieces) from the Graupe gallery to avoid the sequester order and his deposit of those works for *mise en garde* (safekeeping) at Wacker-Bondy.

13. NSLG 00250. From a statement dated June 26, 1945, taken by Allied authorities from Walter Andreas Hofer, a longtime German art dealer who was the director of Goering's art collection.

14. NSLG 00833. Letter from Thomas Grange to the French Commission de Récupération Artistique dated June 6, 1947. Chivian-Cobb affidavit, paragraph 9n2.

15. NSLG 00602. Memorandum from Rose Valland dated July 25, 1960, regarding Paul Graupe's Paris art gallery and artworks stored before the war under *le prête-nom de MUIR* (the pseudonym MUIR), some of which belonged to Friedrich Gutmann. Chivian-Cobb affidavit, paragraph 22.

16. NSLG 00867–88. Letter from Thomas Grange to the Commission de Récupération Artistique dated July 25, 1946. Chivian-Cobb affidavit, paragraph 20.

17. Ibid.

18. NSLG 01848–50. Letter from Arthur Goldschmidt to Paul Simon dated November 20, 1945.

19. Handwritten bill of sale by Friedrich Gutmann dated October 3, 1941.

20. NSLG 03706. Letter from Arthur Goldschmidt to Bernard Goodman, dated February 25, 1946, stating that Karl Haberstock "did not care for the so-called French Impressionist in Germany." NSLG 02949. Letter from Karl Haberstock to a client, dated July 19, 1943, stating that he was interested in dealing only with German masters from the fifteenth to

nineteenth centuries and that the work of French Impressionists "doesn't fit at all with my agenda." Chivian-Cobb affidavit, paragraph 43n10.

21. NSLG 04613–24. Letter from Paul Graupe to Dr. G. Lanz of Zurich, Switzerland, dated May 7, 1942. Chivian-Cobb affidavit, paragraphs 51–53.

22. NSLG 00033–35. Letter from Frederic A. Stern to Dr. J. R. R. Scheller dated March 10, 1946.

23. NSLG 01135–36. ERR inventory of the seized Muir collection. Chivian-Cobb affidavit, paragraph 22.

24. NSLG 03924–29. ERR shipping records dated April 8, 1943.

25. Ibid.

26. Nicholas, *Rape of Europa*, p. 416. Chivian-Cobb affidavit, paragraph 27.

27. Chivian-Cobb affidavit, paragraph 27.

28. NSLG 01025–26. Letter from Dr. Andrae of the West German Federal Service to the French ambassador to West Germany, dated April 4, 1960, regarding the Federal Service's position on the restitution of the Paul Graupe art collection. NSLG 00608–10. French translation of NSLG 01025–26. Chivian-Cobb affidavit, paragraphs 25 and 25n6.

29. NSLG 00033–35. ERR inventory of the seized Muir collection.

30. Nick Goodman deposition, pp. 87–88.

31. NSLG 00867–88. Letter from Thomas Grange to the Commission de Récupération Artistique dated July 25, 1946.

32. Chivian-Cobb affidavit, paragraph 8n1.

33. NSLG 01822–24. Stichting Nederlandsch Kunstbezit records for each of the three Gutmann Impressionist works, all dated January 9, 1947. NSLG 02383. Dr. J. R. R. Scheller letter to the Dutch government's art recovery and restitution agency, SNK, dated January 17, 1946, providing information about the Friedrich Gutmann estate. Chivian-Cobb affidavit, paragraphs 44–45 and 45n11. The form for the landscape states that the buyer was *mojelyk* (possibly) the ERR. Purchase by the ERR is not realistic. The qualification "possibly" suggests that the buyer was unknown to the preparer of the form.

34. NSLG 03717. Letter from Dr. Josefine Leistra, director of the Netherlands Office for Fine Arts, to Lili Gutmann, dated September 27, 1990, regarding the SNK internal notification forms. NSLG 00304–05. Letter from Dr. Josefine Leistra to Lili Gutmann, dated January 17, 1991, regarding her September 27, 1990, letter (NSLG 03717) and Dutch law on wartime art transactions. Chivian-Cobb affidavit, paragraphs 46 and 45n11.

35. NSLG 00867–68. Letter from Thomas Grange to the Commission de Récupération Artistique, Charles Dreyfus, director, dated July 25, 1946. Chivian-Cobb affidavit, paragraph 20.

36. Letter from Thomas Grange to Charles Dreyfus dated December 27, 1946. Chivian-Cobb affidavit, paragraph 39.

37. NSLG 00033–35. Letter from Frederic A. Stern to Dr. J. R. R. Scheller dated March 10, 1946.

38. NSLG 00826, DCS 01538. Letter from Dr. J. R. R. Scheller to Charles Dreyfuss [*sic*] dated August 13, 1946.

39. NSLG 04746. A German-language document, dated February 10, 1950, regarding the 1933 Berlin auction of Wendland's art collection, conducted by Paul Graupe. NSLG 04753–67. Part of a Swiss government report, dated December 16, 1943, on an interrogation of Hans Wendland. Chivian-Cobb affidavit, paragraph 50n12.

40. NSLG 04613–24. Paul Graupe letter to Dr. G. Lanz of Zurich, Switzerland, dated May 7, 1942, describing Graupe's association with Hans Wendland. Chivian-Cobb affidavit, paragraph 50n12.

41. NSLG 01307. Letter from M. Florisoone to (1) A. S. Henraux, the president of the Commission de Récupération Artistique; (2) Monsieur Duval, a *juge d'instruction* in Paris; and (3) Lieutenant Colonel Leonard Cooke, an official of the military government court, U.S. Army. Letter is dated February 21, 1947. Chivian-Cobb affidavit, paragraph 51.

42. NSLG 04613–24. Letter from Paul Graupe to Dr. G. Lanz of Zurich, Switzerland, dated May 7, 1942, describing Graupe's association with Hans Wendland. Chivian-Cobb affidavit, paragraphs 52–53.

43. NSLG 01307. Letter from M. Florisoone to (1) A. S. Henraux, the president of the Commission de Récupération Artistique; (2) Monsieur Duval, *a juge d'instruction* in Paris; and (3) Lieutenant Colonel Leonard Cooke, an official of the military government court, U.S. Army. Letter is dated February 21, 1947, and identifies locations in France where Hans Wendland stored artworks.

44. NSLG 04191. A report dated May 19, 1945, of an interview of Dr. Hans Schneider, of Basel, Switzerland, regarding "persons connected with looted art stored in Switzerland." NSLG 04613–24. Letter from Paul Graupe to Dr. G. Lanz of Zurich, Switzerland, dated May 7, 1942, describing Graupe's association with Hans Wendland. Chivian-Cobb affidavit, paragraph 51.

45. NSLG 00250. Statement taken by Allied authorities from Walter Andreas Hofer dated June 26, 1945. NSLG 00265–66. Translation of a statement from Karl Haberstock, taken at Wurzburg, Germany, dated June 4, 1945.

46. NSLG 04586–89. A German-language document, dated December 29, 1950, regarding Hans Wendland. Chivian-Cobb affidavit, paragraphs 55 and 55n13.

47. Letter from Sotheby and Company, in London, to Bernard Goodman, dated June 3, 1964, appraising the value of Degas's *Landscape with Smokestacks* at £3,500, Degas's *Woman Warming Herself* at £18,000, and Renoir's *Apple Tree in Bloom* at £10,000.

48. Chivian-Cobb affidavit, paragraph 55.

49. Report of Professor Arthur T. von Mehren, p. 5.

50. NSLG 02351. Obituary of Hans Fritz Fankhauser, published in the *National-Zeitung*, Basel, Switzerland, dated December 12, 1966. Chivian-Cobb affidavit, paragraph 38n8.

51. NSLG 01241. Part of a report by the U.S. Strategic Services Art Looting Investigation Unit, dated September 18, 1946, on the interrogation of Hans Wendland. Wendland divorced Fankhauser's sister in the early 1930s.

52. NSLG 04648–52. Swiss government report on Hans Wendland and Hans Fritz Fankhauser dated September 4, 1946. Chivian-Cobb affidavit, paragraphs 56–58.

53. NSLG 04590–95. Swiss government report on Hans Wendland dated September 30, 1954. NSLG 04646–47. Swiss government report on Hans Fritz Fankhauser and Hans Wendland dated August 29, 1946. NSLG 04648–50. Swiss government report on Hans Wendland and Hans Fritz Fankhauser dated September 4, 1946. Chivian-Cobb affidavit, paragraph 56.

54. NSLG 04579–80. Swiss government document, undated, listing artworks sold by Hans Wendland to various purchasers. Chivian-Cobb affidavit, paragraph 57.

55. Letter from Kline to Lerner dated February 20, 1996, p. 3.

56. NSLG 01236–68. Report by the U.S. Strategic Services Art Looting Investigation Unit, dated September 18, 1946, on the interrogation of Hans Wendland.

57. Ibid. at 01239.

58. Ibid. at 01249–50.

59. Ibid. at 01252–55.

60. Ibid. at 01245–46.

61. Ibid. at 01261.

62. Ibid. at 01261–62.

63. Ibid. at 01266.

64. The Office of Strategic Services report was reprinted in the *Art Newspaper*, international edition, January 1999, pp. 6–16.

65. Ibid., p. 14.
66. Ibid., p. 7.
67. Ibid., p. 14.
68. Ibid., p. 7.
69. NSLG 01285. Letter from Otto Wittmann, of the U.S. Strategic Services, to A. S. Henraux, of the Commission de Récupération Artistique, dated September 26, 1946, enclosing a copy of report of the U.S. Strategic Services Art Looting Investigation Unit, dated September 18, 1946, on the interrogation of Hans Wendland.
70. DCS 00673–76. Judgement of French military tribunal, February 10, 1950.
71. Ibid.
72. NSLG 01355. French newspaper article, date unknown, reporting on the trial of Hans Wendland.
73. Ibid.
74. DCS 00673–76. Judgement of French military tribunal, February 10, 1950.
75. NSLG 01355. French newspaper article, date unknown, reporting on the trial of Hans Wendland.
76. Nicholas, *Rape of Europa*, pp. 165–69. Nicholas deposition, pp. 118–19.
77. NSLG 01355.
78. NSLG 01828–29. Letter from Lynn Nicholas to Nick Goodman, undated. Exhibit 16 to Nick Goodman deposition.
79. Druick deposition, pp. 150–54; McCullagh deposition, p. 7.
80. Schab deposition, pp. 160–61, 165.
81. Legend/Diverse television documentary.
82. Lili Gutmann deposition, p. 369.

Chapter Six

1. Lili Gutmann deposition, p. 37.
2. Ibid., p. 40.
3. NSLG 01449. Letter from Lili Gutmann to Allied Commission of Fine Arts dated May 6, 1945.
4. NSLG 01793–94. British document, dated September 5, 1945, containing a "photostated" copy of an undated letter Bernard Goodman addressed to the Dutch government.
5. Lili Gutmann deposition, p. 39.
6. Ibid., pp. 44–45.

7. Ibid., pp. 24, 28.

8. Ibid., pp. 44, 184.

9. Ibid., pp. 181–83.

10. NSLG 00059–64. Claim and settlement agreement between Lili Gutmann, Bernard Goodman, and the trust to which Friedrich Gutmann was indebted. Filed with the Council of Recuperation, Judicial Division, at The Hague. Undated.

11. NSLG 00303–05. Letter from Dr. Josefine Leistra, director of the Netherlands Office for Fine Arts, to Lili Gutmann, dated January 17, 1991, regarding her September 27, 1990, letter (NSLG 03717) and Dutch law on wartime art transactions. Chivian-Cobb affidavit, paragraphs 46 and 45n11.

12. Ibid.

13. NSLG 00756–57. Letter from Lili Gutmann to Rose Valland, dated May 6, 1958.

14. Ibid.

15. Legend/Diverse television documentary.

16. Lili Gutmann deposition, pp. 74–75.

17. Ibid., pp. 56–57.

18. NSLG 00764. Letter from Lili Gutmann to Rose Valland, dated May 22, 1955, requesting copies of photographs of the three Impressionist works that Lili believed to be in Valland's files. NSLG 00705. Letter from Rose Valland to Lili Gutmann, dated June 16, 1955, enclosing copies of photographs of the Renoir and the two works by Degas. NSLG 00689. Letter from Bernard Goodman to Rose Valland, dated June 9, 1956, asking if Valland had photographs of the Renoir and the two works by Degas and, if so, if she could send copies to him. NSLG 00687. Letter from Rose Valland to Bernard Goodman, dated June 13, 1956, enclosing copies of photographs of the Renoir and the two works by Degas.

19. Lili Gutmann deposition, p. 55.

20. NSLG 00028–29. Letter from Bernard Goodman to Detective Inspector Thomas of Scotland Yard, dated July 21, 1956, regarding missing Gutmann art, including the three Impressionist works.

21. NSLG 03757–58. Letter from Bernard Goodman, dated June 23, 1955, to S. Rosenberg, Esq., of Rosenberg and Stiebel art dealership in New York, with whom Bernard had discussed his family's missing art.

22. Ibid.

23. NSLG 00048. Letter from Bernard Goodman, dated June 10, 1955, to S. Rosenberg, Esq., of Rosenberg and Stiebel art dealership in New

York, regarding the possible sale of one of his family's missing works of art.

24. Lili Gutmann deposition, p. 373.

25. DCS 01348–64. Report by the West German Federal Service, dated August 5, 1961, on the status of the search for missing works of art. Chivian-Cobb affidavit, paragraph 25n6.

26. NSLG 0004–07. Letter from Lili Gutmann to F. Mannheimer dated April 12, 1960.

27. NSLG 00385–86. Letter from F. Mannheimer to the West German Federal Service, dated April 23, 1964, presenting Lili and Bernard's claim. Lili Gutmann deposition, exhibit 44A (English translation).

28. NSLG 00799–800. DCS 01478–79. Letter from F. Mannheimer to Rose Valland dated March 31, 1964.

29. NSLG 00030–31. DCS 01407–08. Letter from Rose Valland to F. Mannheimer dated April 7, 1964.

30. Mannheimer relied on Valland's letter to support the conveyance of Gutmann's art into Germany notwithstanding the ERR record that the Degas *Woman Warming Herself* was held in Paris for exchange.

31. DCS 10348–64. Report of the West German Federal Service, dated August 5, 1961, on the status of the search for missing works of art. Chivian-Cobb affidavit, paragraph 25n6.

32. NSLG 00791–92. DCS 01477. Letter from F. Mannheimer to Rose Valland dated June 16, 1964.

33. NSLG 00789–90. Letter from Rose Valland to F. Mannheimer dated June 24, 1964.

34. NSLG 00031–32. DCS 01407–08. Letter from Rose Valland to F. Mannheimer dated April 7, 1964.

35. Ibid.

36. NSLG 00597–600. Statement of Dr. Andrae of the West German Federal Service. Chivian-Cobb affidavit, paragraph 32.

37. NSLG 00377–78. Letter from F. Mannheimer to the West German Federal Service dated April 7, 1964. NSLG 00369. Letter from F. Mannheimer to the West German Federal Service dated May 15, 1967. Chivian-Cobb affidavit, paragraph 30. The Goodmans also translated *ce dépôt de tableaux* into English as "these stored paintings."

38. NSLG 00193–95. Letter from F. Mannheimer to Lili Gutmann and Bernard Goodman dated March 4, 1965.

39. NSLG 00041. Letter from Thomas Grange to Bernard Goodman, dated February 20, 1953, in which Grange referred to Bernard as "Dear Bertie." NSLG 00749–50. Letter from Lili Gutmann to Rose

Valland, dated September 23, 1958, in which she stated that Bernard and Thomas Grange are friends. NSLG 03628. Bernard Goodman's address book, listing Paul Graupe and Thomas Grange. NSLG 00889. Letter from Thomas Grange to Charles Dreyfus of the French Commission de Récupération Artistique, dated October 28, 1947, in which Grange stated that he had been acting as an art agent for Bernard Goodman.

40. Lili Gutmann deposition, pp. 354–56.

41. NSLG 00350–51. West German government document, dated March 4, 1965, regarding the Goodman/Gutmann claim. NSLG 00345–46. Letter from Dr. Andrae of the West German Federal Service to F. Mannheimer, dated May 27, 1964. NSLG 00347. Letter from A. J. van der Leeuw of the Dutch government to F. Mannheimer dated December 21, 1965. NSLG 00030–31. Appendix 17. Chivian-Cobb affidavit, paragraphs 35–36.

42. NSLG 000345–46. Letter from Dr. Andrae of the West German Federal Service to F. Mannheimer dated May 27, 1964. Chivian-Cobb affidavit, paragraph 35.

43. NSLG 00347. Letter from A. J. van der Leeuw of the Dutch government to F. Mannheimer dated December 21, 1965. Chivian-Cobb affidavit, paragraph 34.

44. NSLG 00216–18. Letter from F. Mannheimer to Lili Gutmann dated February 1, 1966.
DCS 01497–98. Chivian-Cobb affidavit, paragraph 36.

45. NSLG 04545–48. Terms of official claim and settlement filed with the West German government, dated January 17, 1967.

46. NSLG 00505–06. The statutory declarations signed by Bernard Goodman and Lili Gutmann in December 1966, renouncing future applications for compensation for the four works of art named in the claim. Lili Gutmann deposition, exhibits 53, 54.

47. NSLG 1700. Letter from Bernard Goodman to the United Restitution Organization, dated January 30, 1991, regarding his claim against East Germany for the other 50 percent of the settlement.

48. Lili Gutmann deposition, pp. 98–99.

49. Ibid., pp. 410–12.

50. Nick Goodman deposition, pp. 22–23 (statement of Thomas Kline). In response to the Goodmans' demand, the buyer of the Renoir filed suit in London asking the court to determine the rightful owner. *Mallard Corporation v. Nick and Simon Goodman and Lili Gutmann,* High Court of Justice, Queen's Bench Division (1997 folio no. 1718, August 11, 1997).

51. Lili Gutmann deposition, p. 411.

52. Ibid., pp. 156–57.
53. Parke-Bernet, in addition to having an auction house in New York, had an office in London with which Bernard Goodman had dealings (NSLG 3593–94).
54. *Los Angeles Times*, Friday, July 19, 1996, p. B1. Nick Goodman deposition, pp. 153–54.
55. Nick Goodman deposition, pp. 36–37.
56. Declaration of Eva Schultze-Dumbsky, paragraphs 3–4, 8–10.
57. Nick Goodman deposition, p. 40.
58. Ibid., pp. 117–18.
59. Ibid., pp. 97, 110, and exhibit 4.
60. Lili Gutmann deposition, pp. 161–64.
61. SHOAH interview, p. 46.
62. Lili Gutmann deposition, pp. 87–88, 120–21.
63. Declaration of Dr. Griebart, paragraphs 20, 29.
64. Lili Gutmann deposition, pp. 76, 122–25.
65. Ibid., pp. 110–13.
66. Simon Goodman deposition, pp. 22–25.
67. Ibid., pp. 24–25.
68. NSLG 00085. Letter from Lili Gutmann to Nick Goodman dated January 17, 1995. Nick Goodman deposition, exhibit 5.
69. Nick Goodman deposition, p. 258.
70. NSLG 00094–95. Letter from Nick Goodman to Lili Gutmann, dated June 31 [*sic*], 1995. Lynn Nicholas deposition, p. 12.
71. NSLG 01828–29. Letter from Lynn Nicholas to Nick Goodman, undated, providing a list of "useful" people. Nick Goodman deposition, exhibit 16.
72. Nick Goodman deposition, pp. 248–49; Simon Goodman deposition, p. 38.
73. NSLG 01876. Summary of Nick Goodman's personal diary, chronicling his search efforts. Nick Goodman deposition, exhibit 24.

Chapter Seven

1. Defendant's motion for summary judgment and memorandum of law in support, filed January 13, 1998.
2. Plaintiffs' memorandum of law in opposition to defendant's motion for summary judgment, dated January 27, 1998, p. 7.
3. Ibid., pp. 1–3, 6–10.
4. Report of Lynn H. Nicholas.

5. Ibid., p. 1.

6. Ibid., pp. 9–10.

7. Ibid., pp. 8–9.

8. Deposition of Lynn Nicholas, p. 28.

9. Ibid., p. 192.

10. Defendant's reply memorandum of law in support of motion for summary judgment, dated February 6, 1998, pp. 5–9.

11. Plaintiffs' memorandum of law in opposition to defendant's motion of summary judgment, dated January 27, 1998, p. 13n5.

12. Ibid., p. 6.

13. Defendant's reply memorandum in support of motion for summary judgment, dated February 6, 1998, pp. 3–5.

14. Defendant's memorandum of law in support of motion for summary judgment, dated January 13, 1998, pp. 10–13.

15. This common law principle is documented and discussed by Ralph E. Lerner, "The Nazi Art Theft Problem and the Role of the Museum: A Proposed Solution to Disputes over Title," *New York University Journal of International Law and Politics* 31 (1998): 15, 16.

16. Cases cited in defendant's memorandum of law in support of summary judgment, dated January 13, 1998, pp. 10–11. See also Lerner, "The Nazi Art Theft Problem," pp. 29–34.

17. *DeWeerth v. Baldinger,* 836 F.2d 103, 104–6 (2d Cir. 1987).

18. 836 F.2d at 110.

19. 836 F.2d at 108.

20. 836 F.2d at 110.

21. 836 F.2d at 112.

22. *Autocephalous Greek Church of Cyprus v. Goldman & Feldman Fine Arts, Inc.,* 917 F.2d 278, 288–89 (7th Cir. 1990). The United States Court of Appeals for the Seventh Circuit dealt with a similar question under Indiana law. The district court had held that, under Indiana law, the discovery rule applied and that "it is the court's responsibility to determine, based on the facts of each case, when the cause of action accrues," and the Court of Appeals agreed. But that court disagreed with the Second Circuit's opinion in the *DeWeerth* case that the Court of Appeals should itself apply the state law to the facts "de novo." Rather, the decision of the district court should be upheld unless found on appeal to be "clearly erroneous."

23. Plaintiffs' memorandum of law in opposition to defendant's motion for summary judgment, dated January 27, 1996, pp. 14–15.

24. Nicholas report, p. 10.

25. Nicholas deposition, pp. 152–53.

26. Pinkerton report, p. 7.

27. Chivian-Cobb affidavit, paragraphs 66–69.

28. *Solomon R. Guggenheim Foundation v. Lubell*, 77 N.Y. 2d 311, 320 (1991).

29. 77 N.Y. 2d at 315, 318.

30. *DeWeerth v. Baldinger*, 38 F.3d 1266, 1273, 1276 (2d Cir. 1994).

31. 77 N.Y. 2d at 321.

32. Defendant's memorandum of law in support of motion for summary judgment, dated January 13, 1998, pp. 13–14.

33. Defendant's memorandum of law in support of motion for summary judgment, dated January 13, 1996, p. 14.

34. Pinkerton report, p. 2.

35. Ibid.

36. Ibid., p. 3.

37. NSLG 01876. Summary of Nick Goodman's personal diary, chronicling his search efforts.

38. Pinkerton report, p. 4.

39. Ibid., p. 2.

40. Linda F. Pinkerton, "Due Diligence in Fine Art Transactions," *Case Western Reserve Journal of International Law* 22 (1990): 16. Exhibit 2 to deposition of Linda F. Pinkerton.

41. Motion of partial summary judgment for statute of limitations defense, dated October 22, 1997.

42. Memorandum of law in support of plaintiffs' motion for partial summary judgment on statute of limitations defense, dated October 22, 1997, pp. 4–12.

43. Defendants' response to plaintiffs' motion for partial summary judgment on statute of limitation defense, dated December 1, 1997, pp. 5–8.

44. Plaintiffs' reply memorandum in support of motion for partial summary judgment on statute of limitation issues, dated December 8, 1997, pp. 4–10.

45. Report of Professor von Mehren on foreign law issues, pp. 3, 8.

46. Ibid., p. 8.

47. DCS 1574. Emile Wolf's passport.

48. Defendants' memorandum of law in support of motion for summary judgment, dated January 13, 1998, p. 15.

49. Plaintiffs' memorandum of law in opposition to defendant's motion for summary judgment, dated January 27, 1998, p. 21.

50. Defendant's reply memorandum in support of motion for summary judgment, dated February 6, 1998, pp. 3–4.

51. "Three-Year Review: An Open Letter to the Bar," by Chief Judge
 Marvin E. Aspen, dated November 19, 1998, p. 9.

Chapter Eight

1. Quote from Legend/Diverse television documentary.
2. Letter from Nick Goodman to Daniel Searle dated June 30, 1998.
3. Order dated June 20, 1997.
4. Lili Gutmann deposition, pp. 455–56.
5. Ibid., p. 454.
6. Letter from Daniel Searle to Lili Gutmann dated November 18, 1997.
7. Letter from Lili Gutmann to Daniel Searle dated November 25, 1997.
8. Ibid.
9. Letter from Daniel Searle to Lili Gutmann dated November 26, 1997.
10. Letter from Lili Gutmann to Daniel Searle dated December 2, 1997.
11. Letter from Thomas R. Kline to Howard J. Trienens dated January 13, 1998.
12. Letter from Daniel Searle to Lili Gutmann dated November 26, 1997.
13. Advertisement in *Forward* dated February 27, 1998.
14. Release of the Art Institute of Chicago dated August 13, 1998.
15. Release and settlement agreement dated August 13, 1998, paragraph 2.
16. Letter from counsel for the Art Institute to counsel for the Goodmans and Searle dated November 4, 1998, enclosing the appraisal of Richard L. Feigen and Company dated October 12, 1998, and the appraisal of Christie's dated October 30, 1998.
17. Letter from counsel for the Goodmans to counsel for the Art Institute dated November 17, 1998, pp. 6, 7.
18. Telephone call from counsel for the Art Institute to counsel for the Goodmans, December 1, 1998.
19. Lee Rosenbaum, *Wall Street Journal*, January 14, 1999, p. A18.
20. Letter from counsel for the Art Institute to counsel for the Goodmans and Searle dated April 21, 1999, enclosing the revised appraisal of Christie's dated April 13, 1999.
21. Letter from counsel for the Goodmans to counsel for the Art Institute dated May 12, 1999.
22. Lee Rosenbaum, *Wall Street Journal*, January 14, 1999, p. A18.
23. "Eugen Gutmann and His Family (From Recollections by His Grandson, Bernard F. Goodman, Tubinger, May, 1991)," attachment E to letter from Kline to Lerner dated February 7, 1996.
24. *Chicago Tribune*, June 12, 1999, section 1, p. 5.

Chapter Nine

1. Lee Rosenbaum, "Will Museums in U.S. Purge Nazi Tainted Art?" *Art in America,* November 1998, p. 39.
2. See Judith H. Dobrzynski, "No Simple Solutions in Meting out Justice in Claims to Looted Art," *New York Times,* September 5, 1998, p. B3, reporting that the Seattle Art Museum, which had been given a Matisse allegedly stolen by the Nazis, had sued the art dealer who had sold it to the donor.
3. Plaintiffs' memorandum of law in opposition to defendant's motion for summary judgment, dated January 27, 1998, p. 21.
4. "Report of the AAMD Task Force on the Spoilation of Art during the Nazi/World War II Era (1933–1945)," June 4, 1998.
5. Lee Rosenbaum, *Wall Street Journal,* January 14, 1999, p. A18. The article also stated that the settlement agreement was unraveling. This was incorrect. The Goodmans' disappointment with the results of the appraisals of the value of *Landscape with Smokestacks* did not alter the binding effect of the settlement agreement.
6. Ibid.
7. Tim Pozzi, "Television and Radio: Pick of the Day," *London Daily Telegraph,* June 28, 1998, p. 18.
8. *Chicago Tribune,* June 12, 1999, section 1, p. 5.
9. Chivian-Cobb affidavit, paragraph 64.